ALBUQUERQUE

IMPRESSIONS

photography by KIP MALONE

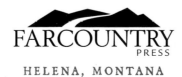

FARCOUNTRY
PRESS

HELENA, MONTANA

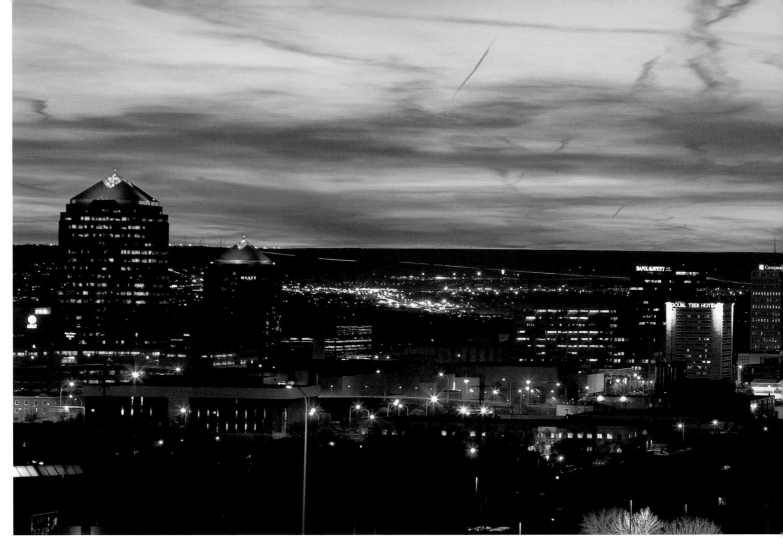

FRONT COVER: Hot-air balloons take to the sky during the Albuquerque International Balloon Fiesta.

BACK COVER: A heart-shaped chile ristra is displayed on a courtyard gate.

TITLE PAGE: This field in the Río Grande Valley north of Albuquerque is plowed and ready for planting.

ISBN 10: 1-56037-467-5
ISBN 13: 978-1-56037-467-1

© 2007 BY FARCOUNTRY PRESS
PHOTOGRAPHY © 2007 BY KIP MALONE

FOR MORE INFORMATION ABOUT OUR BOOKS, WRITE FARCOUNTRY PRESS, P.O. BOX 5630, HELENA, MT 59604;
CALL (800) 821-3874; OR VISIT WWW.FARCOUNTRYPRESS.COM.

CREATED, PRODUCED, AND DESIGNED IN THE UNITED STATES.
PRINTED IN CHINA.

12 11 10 09 08 07 1 2 3 4 5 6

ABOVE: Contrails and clouds create the dreamy look of a watercolor painting as city lights begin to sparkle at sunset. Located at 5,500 feet in the high desert, Albuquerque is graced with more than 310 days of sunshine a year.

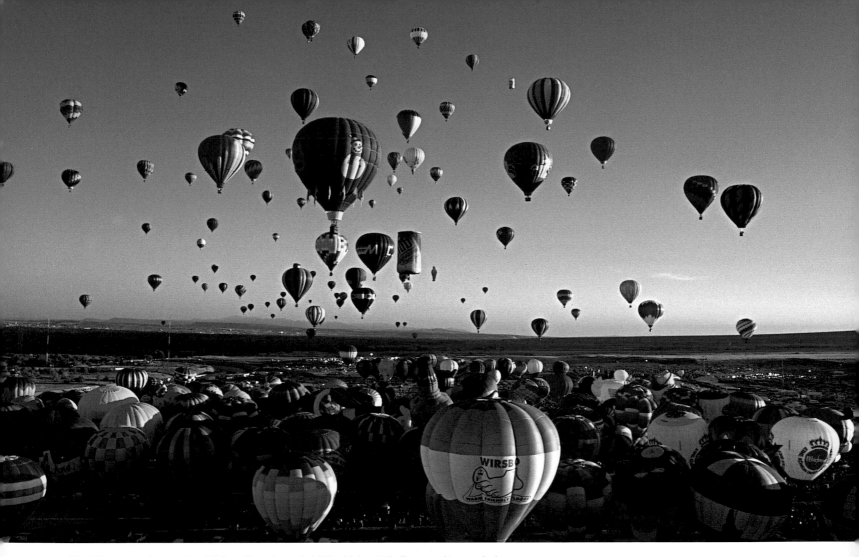

ABOVE: The Albuquerque International Balloon Fiesta began in 1972 with just 13 balloons and is now the largest balloon event in the world, drawing more than 700 balloons and thousands of spectators.

FACING PAGE: This view shows the top of a balloon in flight, photographed from another balloon as it passed over.

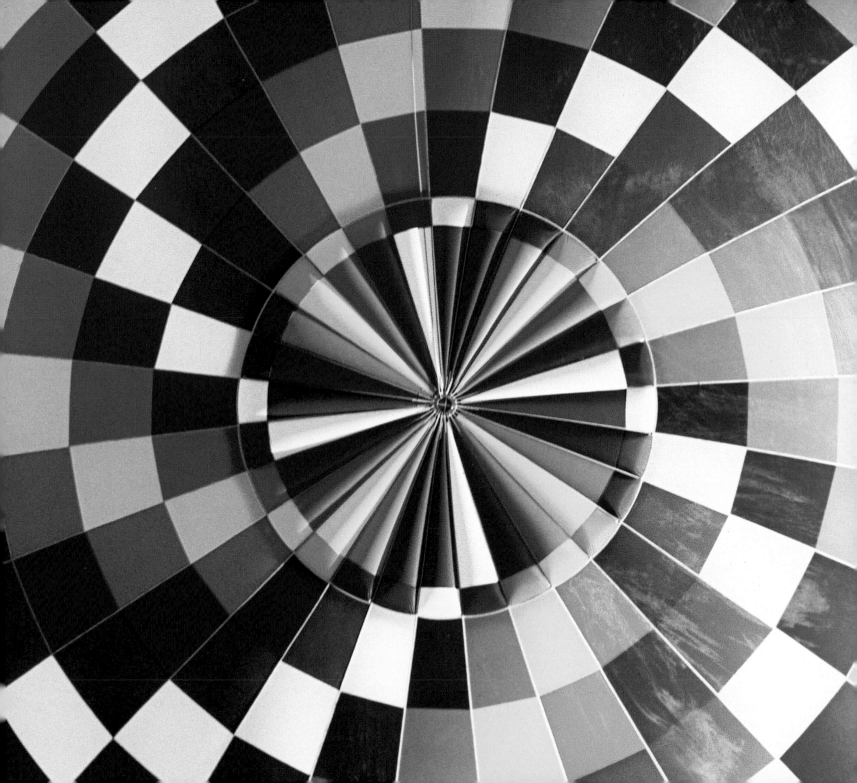

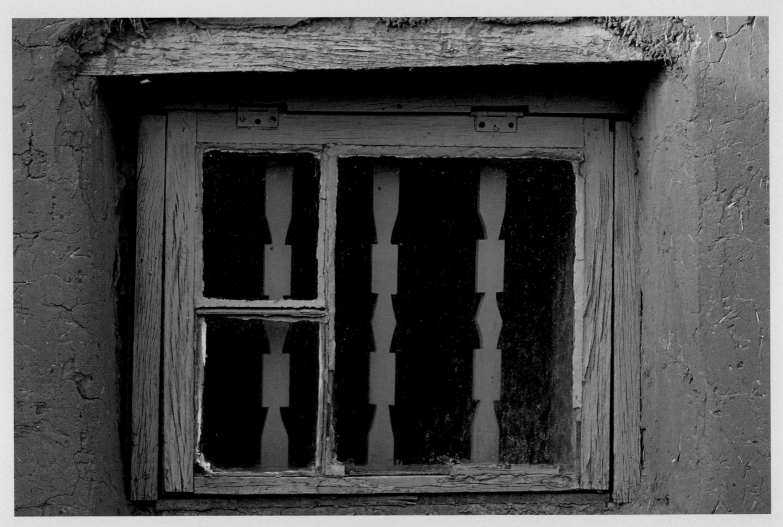

This blue window frame harkens back to the Moorish-Spanish architectural style brought to New Mexico by early settlers.

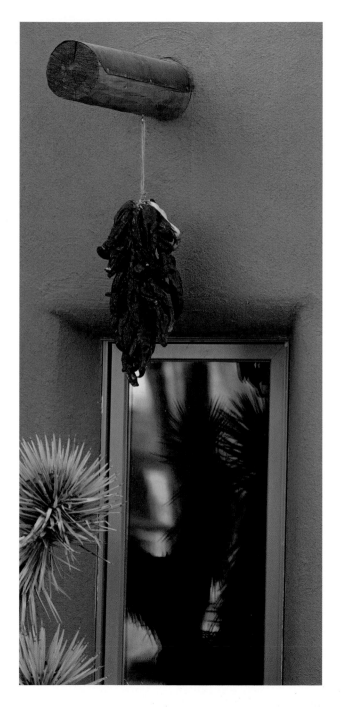

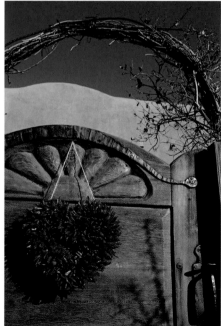

FAR LEFT: Most peppers turn red or even purplish-black when ripe, usually by mid-September in New Mexico. They keep their color and flavor for months when hung to dry in the open air.

LEFT, TOP: Strong, versatile adobe bricks fashioned from mud and straw have been used for centuries in the Río Grande Valley.

LEFT, BOTTOM: A heart of chile peppers adorns a courtyard gate.

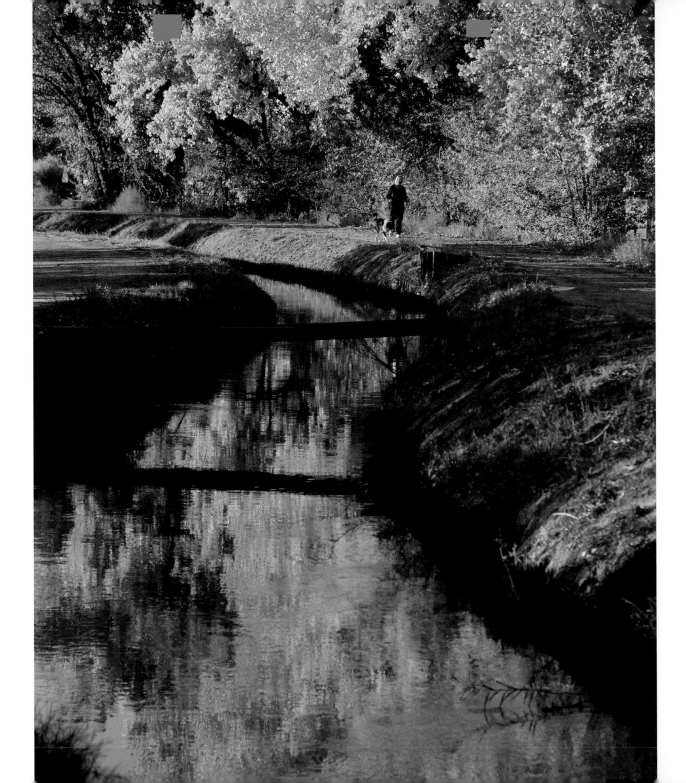

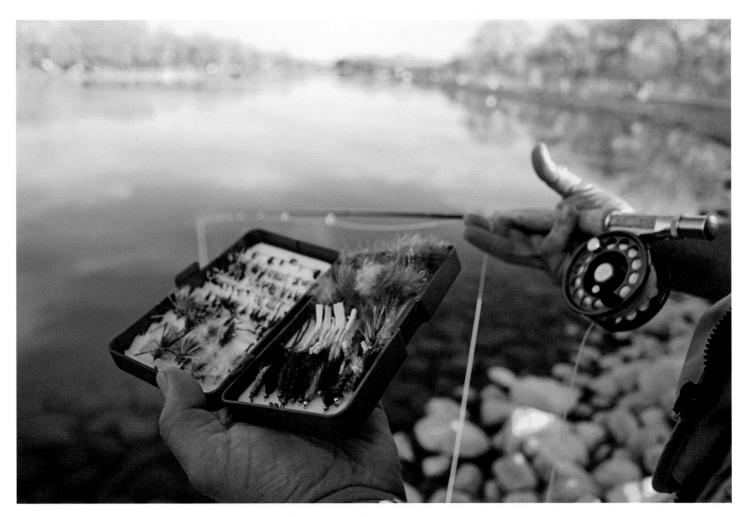

ABOVE: An angler shows off his fly-fishing tackle at the city's popular Tingley Beach.

FACING PAGE: Numerous *acequias*, or "irrigation ditches," bring water into the Middle Río Grande Conservancy District. In addition to agricultural use, the waterways nurture shady thickets and form a network of informal pathways.

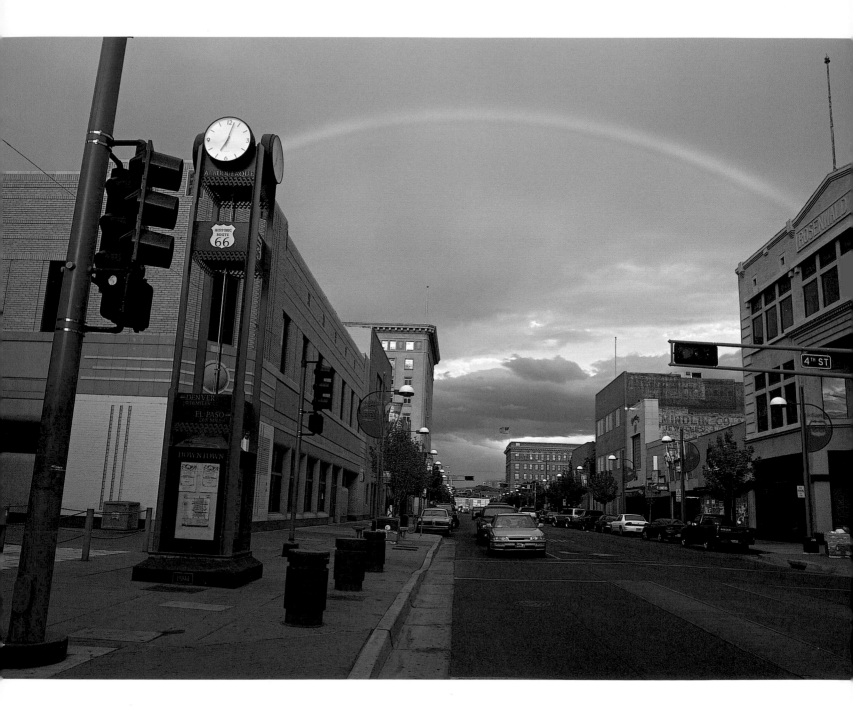

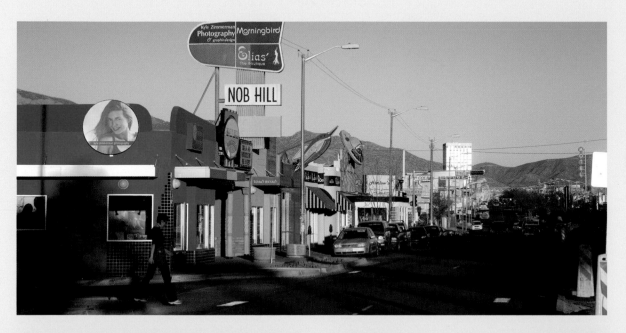

LEFT: Nob Hill shopping district, close to the University of New Mexico, is known for hip shops, trendy fusion cuisine, and eclectic art galleries.

BOTTOM LEFT: Located across the street from the University of New Mexico, Frontier Restaurant has been attracting and feeding students since 1971. The walls of the dining areas display striking works by local and national artists.

BOTTOM RIGHT: Staying power: Skip Maisel's Indian Jewelry and Crafts store is one of the oldest businesses downtown. Indian art and silver-and-turquoise jewelry are renowned worldwide for their exquisite craftsmanship and artistry.

FACING PAGE: It's not all dry heat in the desert. Rainbows are a common sight at certain times of year. Albuquerque averages 8.5 inches of rainfall annually. Right next door, the Sandia Mountains average 40 inches!

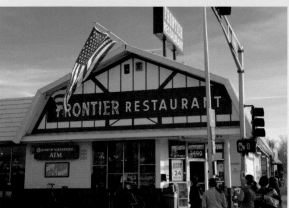

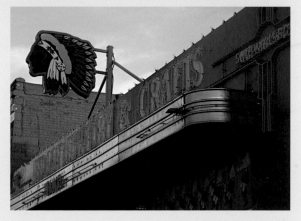

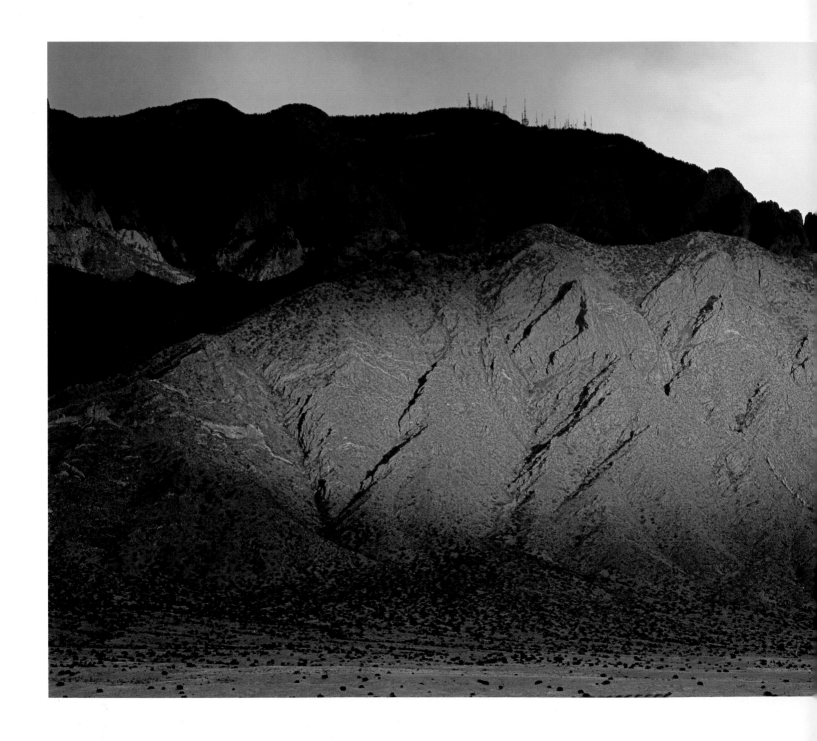

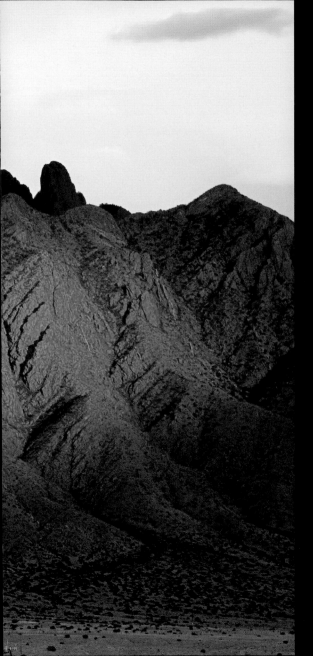

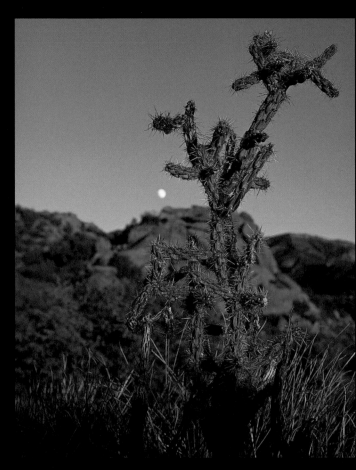

ABOVE: Jumping cholla is so named because if you accidentally brush up against it, the spines "jump" deep into your skin. You'll only be oblivious to this cactus once.

LEFT: Located east of Albuquerque, the Sandia Mountains were created during the formation of the Río Grande Rift, a fracture in the earth's crust that extends more than 450 miles from Leadville, Colorado, to Las Cruces, New Mexico. Fossil hunters find innumerable treasures embedded in the mountains' limestone cap.

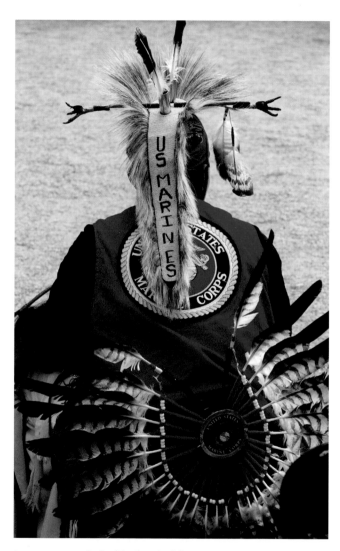
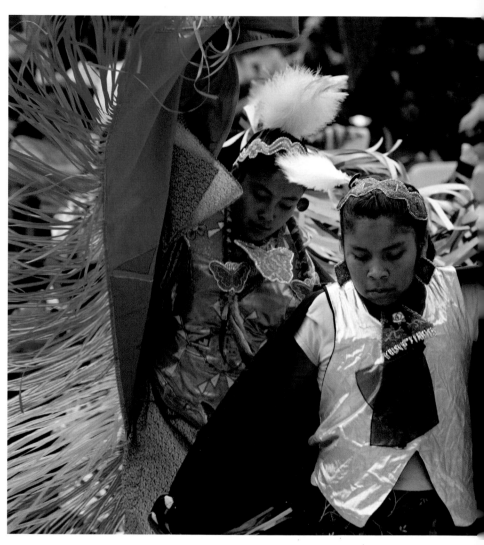

A convergence of colorful cultural celebrants. A Native American dancer proudly displays his status as a veteran of the United States Marine Corps. Youngsters show off their costumes and fancy steps in the Indian Village during the seventeen-day New Mexico State Fair.

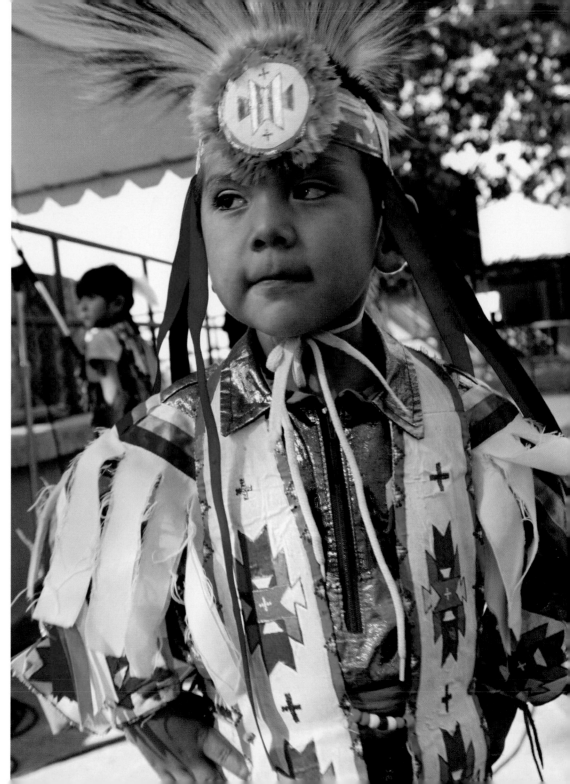

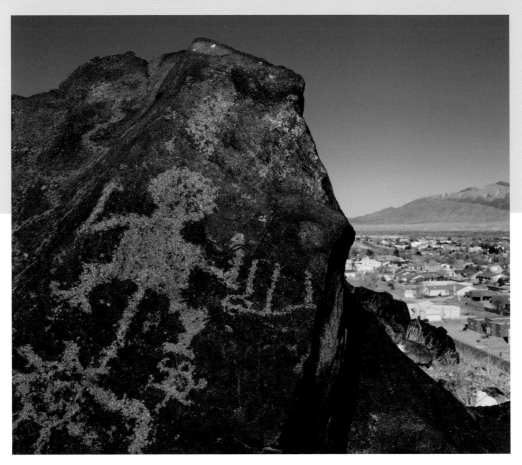
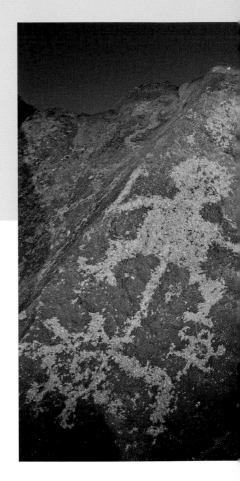

More than 400 years ago, people etched approximately 15,000 petroglyphs into boulders on the volcanic escarpment west of the Río Grande. Today they are preserved within Petroglyph National Monument. Hikers who climb to the site can contemplate the contrasts between ancient ways and modern-day Albuquerque.

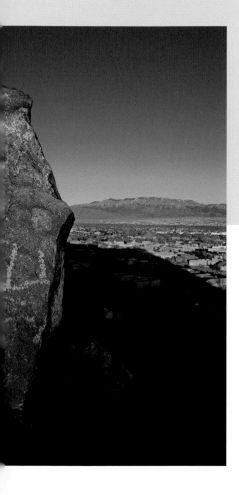

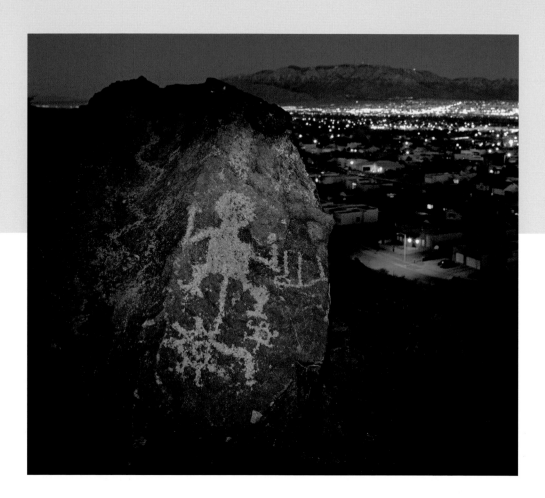

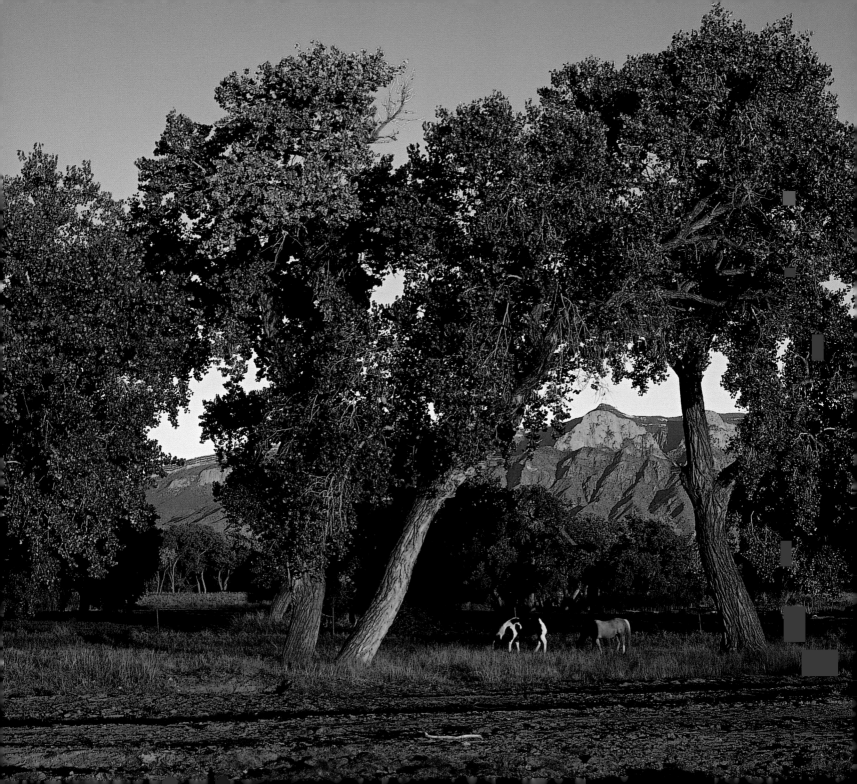

LEFT: Spanish conquistadors brought horses to the Americas in the sixteenth century, and equines remain an important part of life in New Mexico today.

BELOW: A dusting of winter snow highlights the dramatic contours of the Sandia Mountains. Hikers find more than 100 miles of trails in the range.

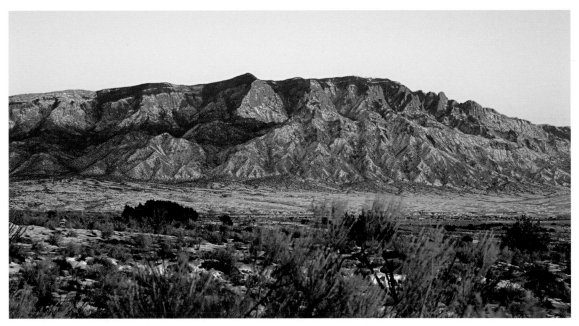

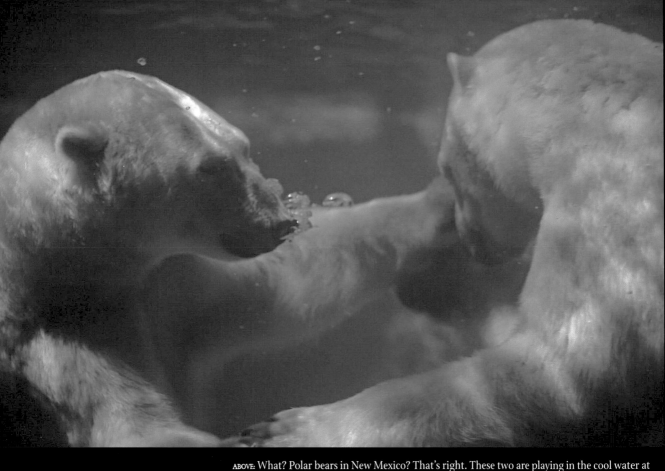

ABOVE: What? Polar bears in New Mexico? That's right. These two are playing in the cool water at the Río Grande Zoo. The zoo is also home to elephants, rhinos, giraffes, gorillas, toucans, Komodo dragons, piranhas, wolves, seals, tigers, koalas, parrots, and many amphibians and reptiles.

FACING PAGE: A youngster is spellbound by this glowing tank full of jellyfish in the Albuquerque Aquarium. Other species featured at the aquarium include reef fish, eels, turtles, and sand tiger, blacktip, and nurse sharks.

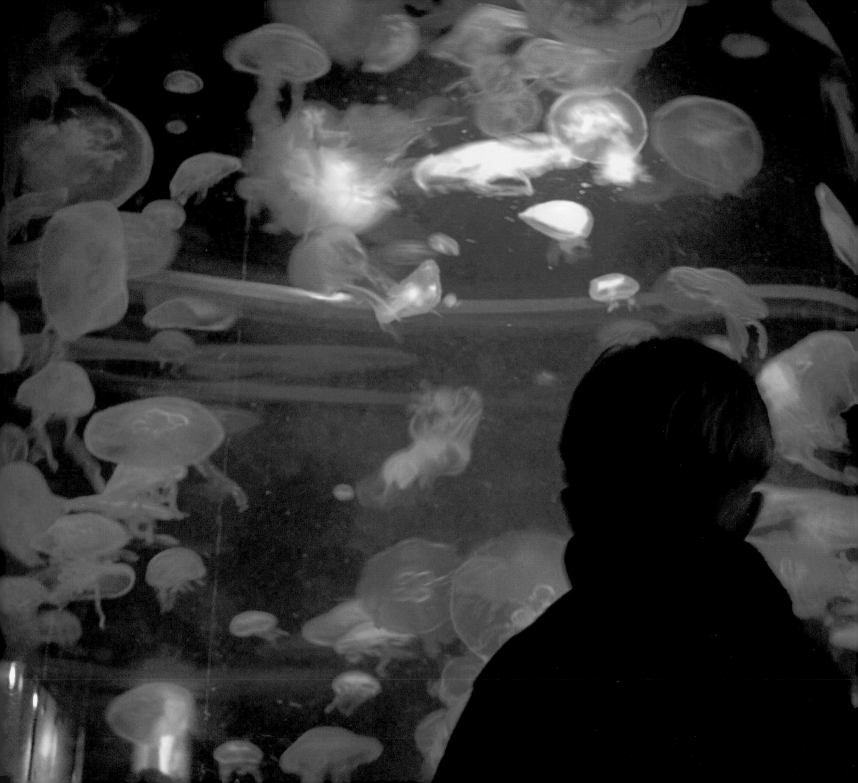

ABOVE: Albuquerque potter Bennin Duran created these giant ceramic pots and decorated them with traditional designs.

RIGHT: Cow skulls, chile ristras, and handwoven blankets are the heart of Southwestern tradition and décor.

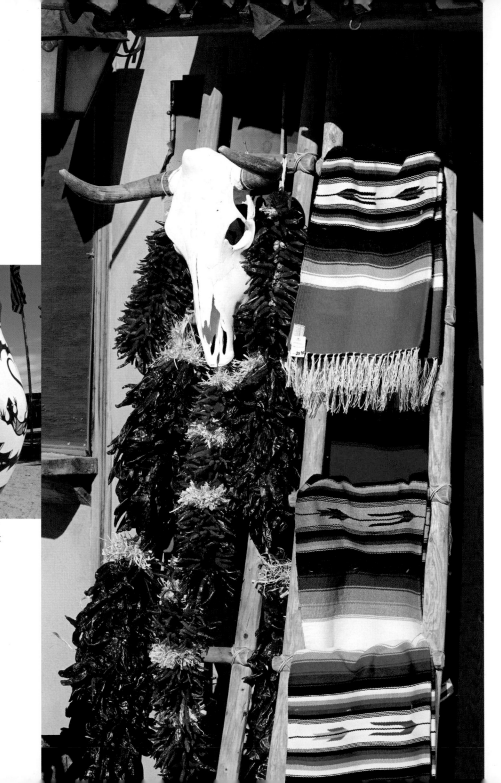

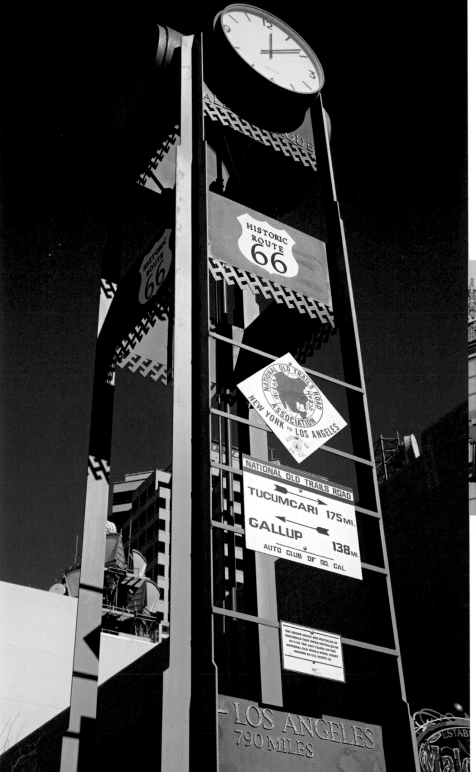

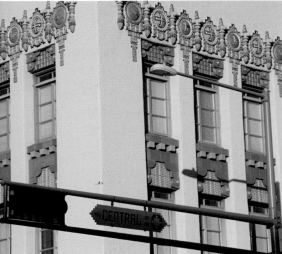

ABOVE: The KiMo Theater, built in 1927, sports outstanding Pueblo Deco architectural flourishes.

LEFT: The clock tower marks time in the heart of historic downtown Albuquerque. Trendy independent shops line both sides of Historic Route 66.

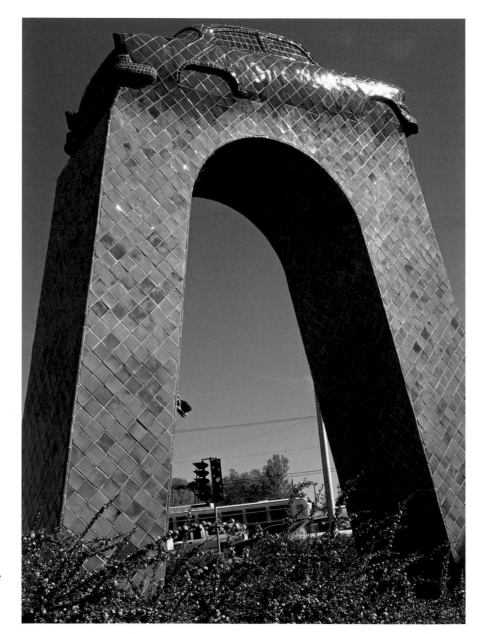

RIGHT: Artist Barbara Grygutis created this arch called *Cruising San Mateo* for the city's public art program.

FACING PAGE: Imagine putting together a jigsaw puzzle of this image! The Bank of Albuquerque doesn't really have the checkered history suggested by its reflection in an adjacent building.

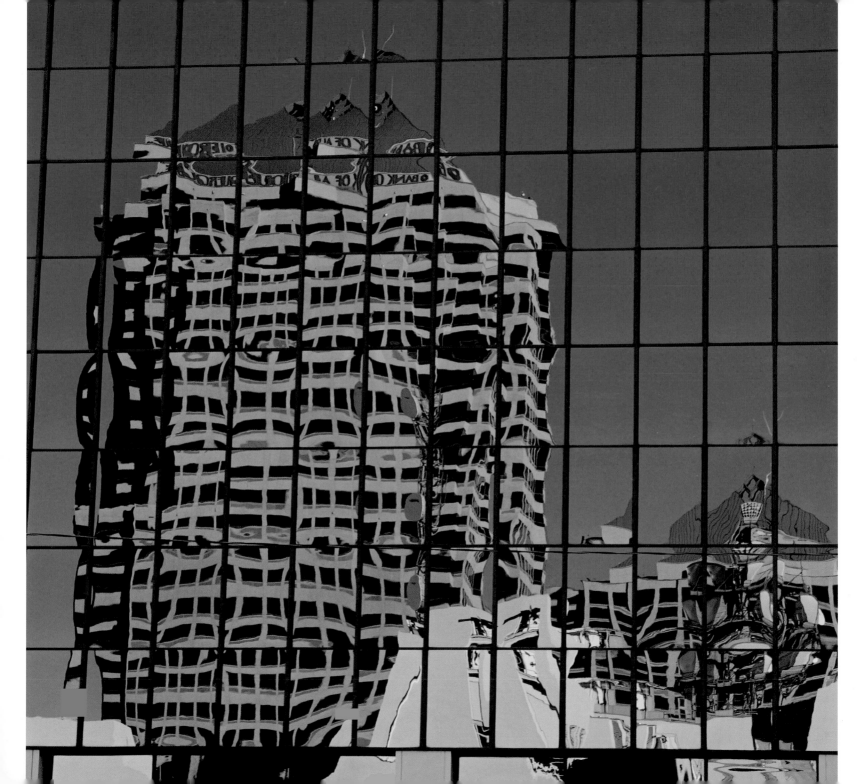

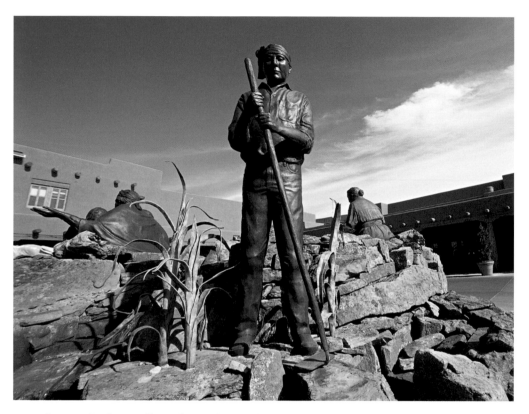

ABOVE: *The Farmer* by Sharon Fullingim honors the agricultural traditions of the desert Southwest. Albuquerque was originally a farming village and military outpost along the Camino Real, between Chihuahua and Santa Fe.

RIGHT: Luis Jimenez created this sculpture in 1996. Reportedly, he intentionally misspelled the words "fiesta" and "jarambe" in the work's title to make a point—perhaps about misconceptions about Mexican culture.

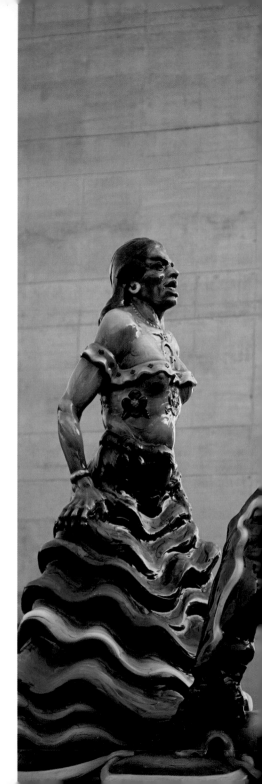

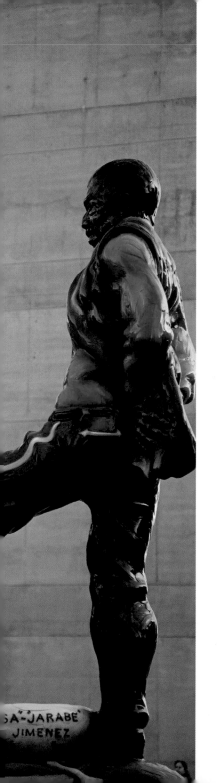

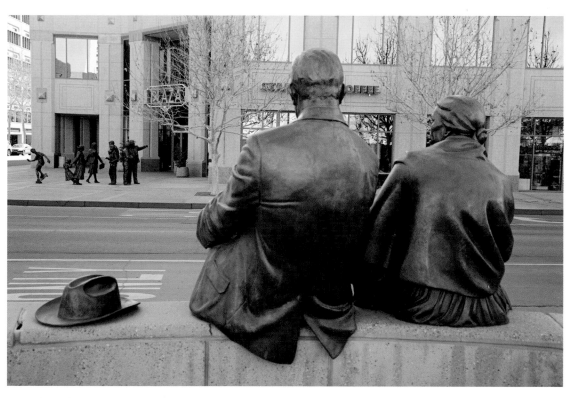

ABOVE: *El Senador*, sculpted by Cynthia and Mark Rowland, honors Senator Dennis Chavez.
Across the street, Glenna Goodacre's *Sidewalk Society* graces the corner.

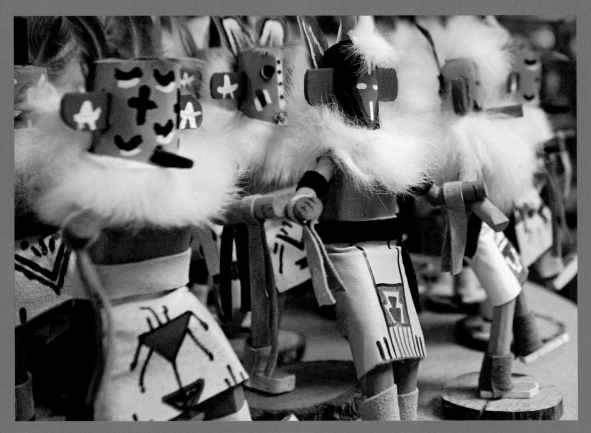

ABOVE: Kachina dolls were traditionally made by the Zuni tribe. These, however, were fashioned by Navajo people and are for sale in Old Town. Kachinas are regarded as spirits that can bridge between worlds.

FACING PAGE: Many of the eclectic shops in Old Town feature pottery with decorative traditions that go back many centuries. Some designs are unique to New Mexico; others show Mexican and Central American influences.

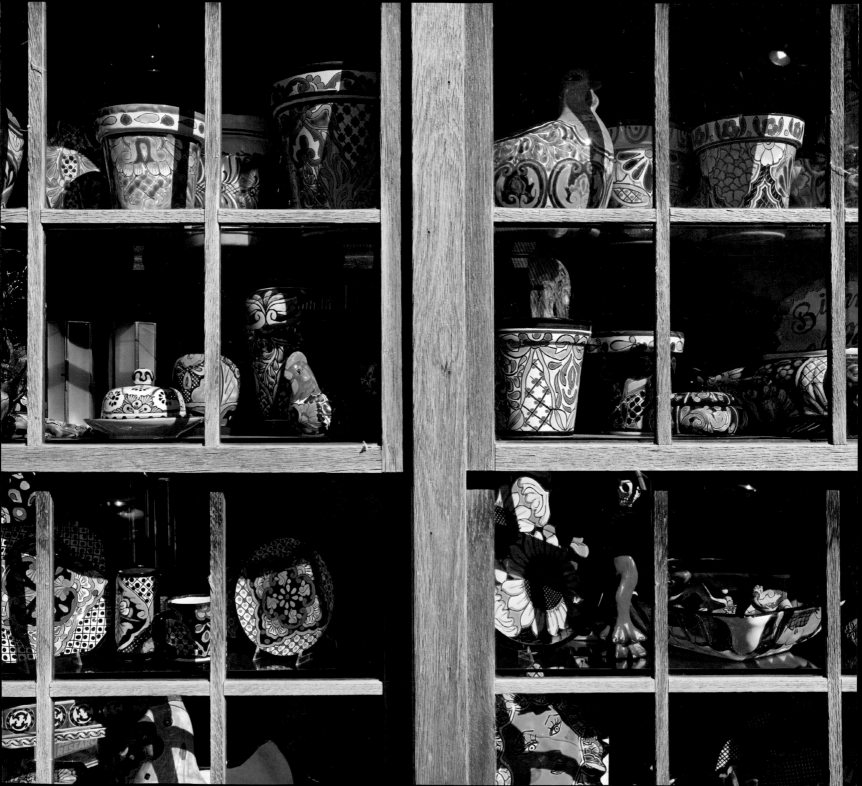

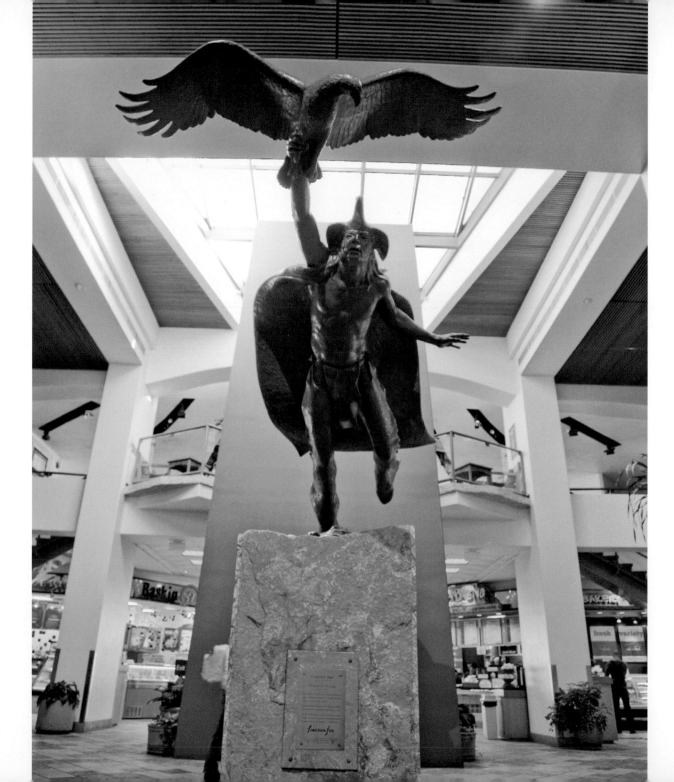

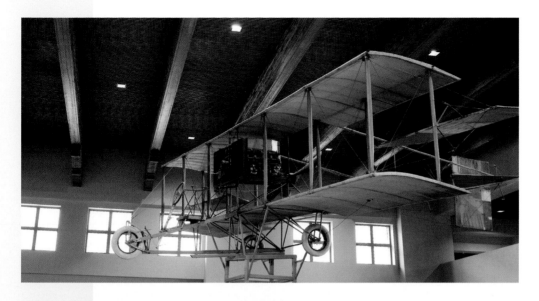

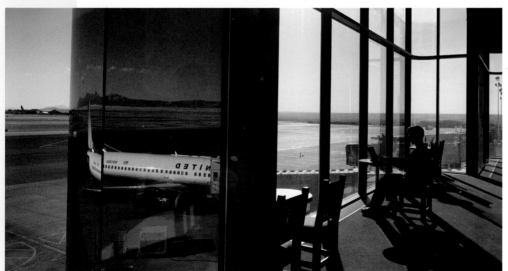

LEFT, TOP: The 1914 Ingram-Foster biplane hangs below the rustic vigas, or wooden beams, in Albuquerque International Sunport. Located in the back of the plane, the propeller pushed, rather than pulled, the biplane through the air.

LEFT, BOTTOM: The observation deck at the airport provides unobstructed views of domestic air traffic as well as military aircraft from Kirtland Air Force Base.

FACING PAGE: More than one hundred pieces of art adorn the airport, inside and out. Sculptor Lincoln Fox's *Dream of Flight* is in the main terminal.

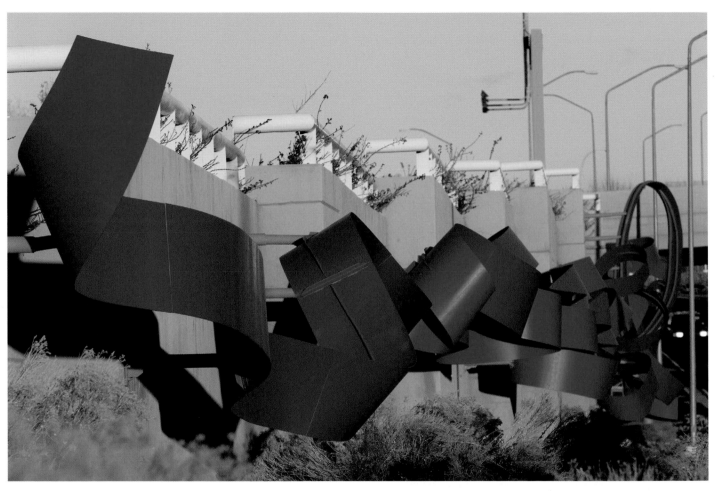

ABOVE: *La Serpentina* by Rogelio Madero winds gracefully through the grounds outside the Albuquerque International Sunport. This airy representation of a traditional party ribbon is more than 800 feet long and weighs 12,300 pounds.

FACING PAGE: These ceramic chile peppers adorning a shop mimic the real thing, which are often hung out to dry in breezy spots out of direct sunlight.

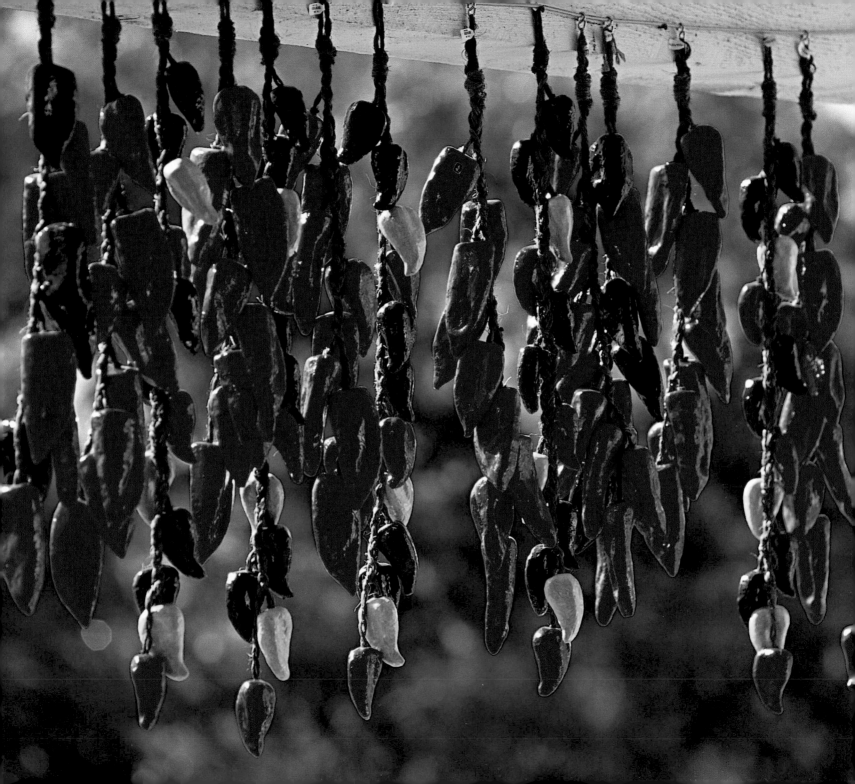

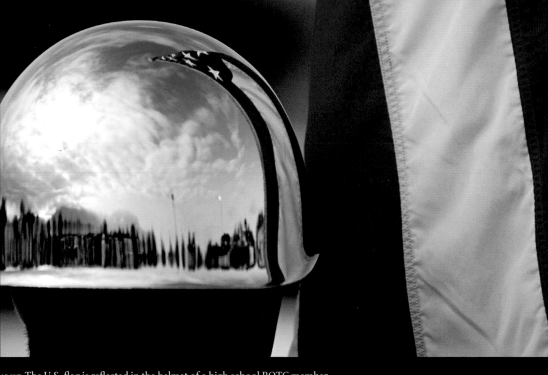

ABOVE: The U.S. flag is reflected in the helmet of a high school ROTC member as he marches in a parade in downtown Albuquerque.

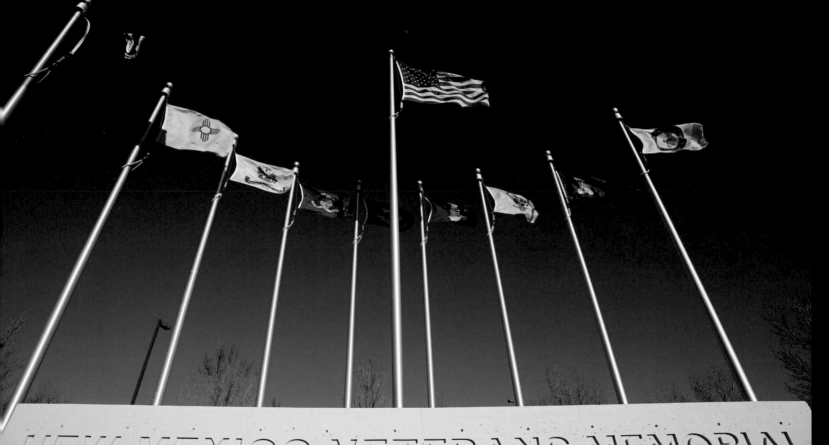

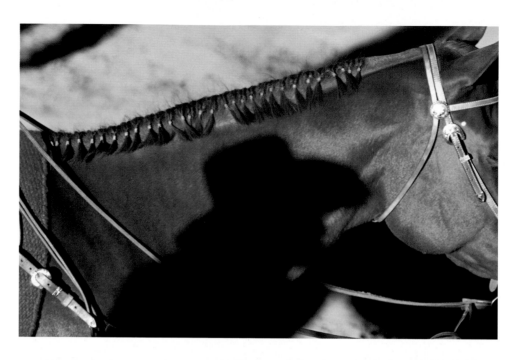

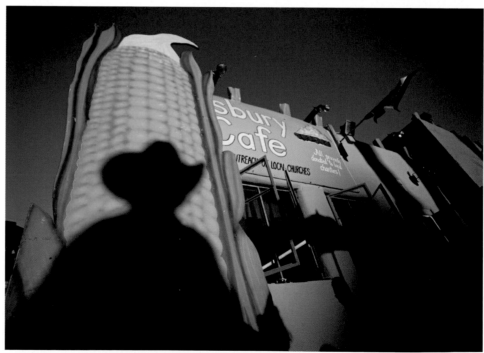

RIGHT, TOP: The low rays of sunset catch a cowboy ready to compete in the rodeo arena. State Fair Rodeo events include steer wrestling, barrel races, and bronc and bull riding.

RIGHT, BOTTOM: Local churches unite to bake and donate hundreds of pies for the annual State Fair. The fruits of their labor are sold at the Asbury Café, with all proceeds donated to charity.

FACING PAGE: Route 66, world famous for the Americana splayed along its roadsides, also features some spectacular sunsets.

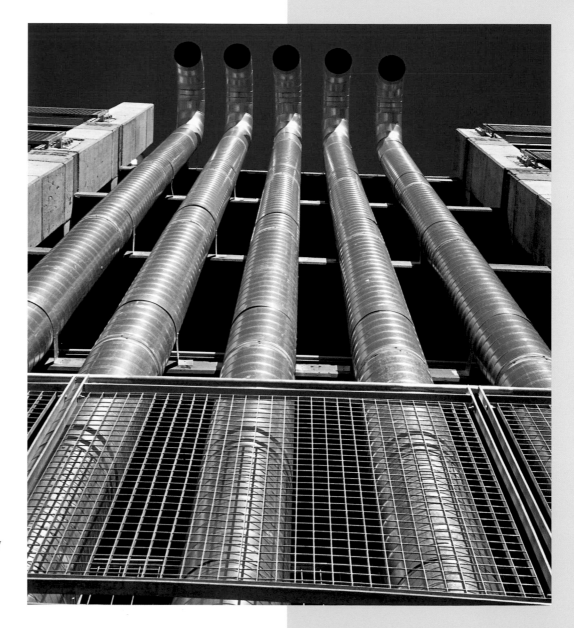

RIGHT: Ventilation pipes seem ready to burst into a jazz medley at this uniquely designed downtown building.

FACING PAGE: A play of shapes emerges at the modern Albuquerque City Hall.

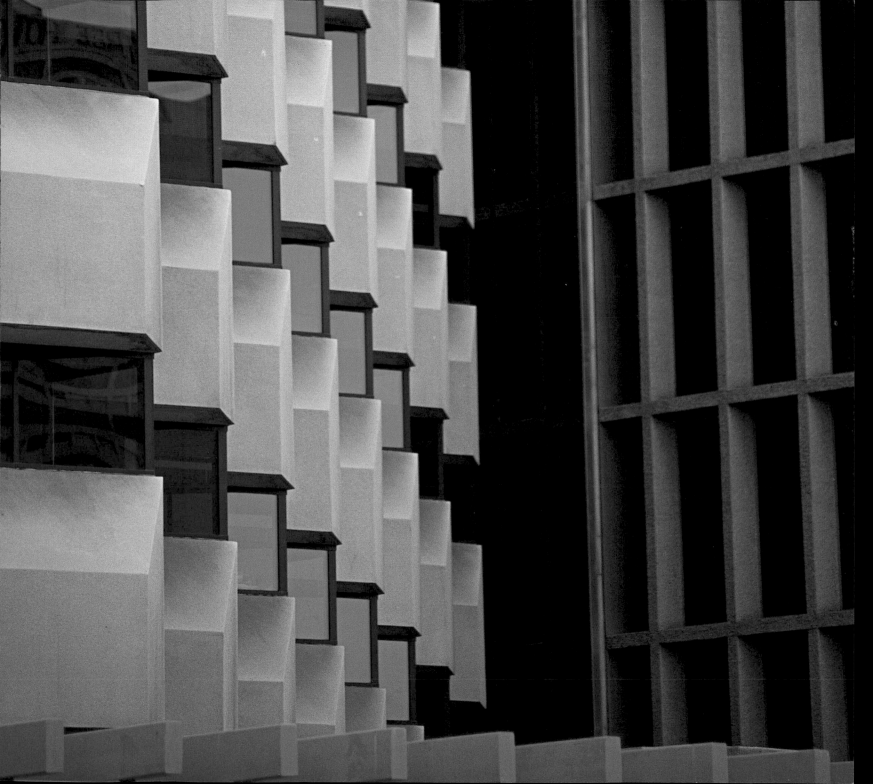

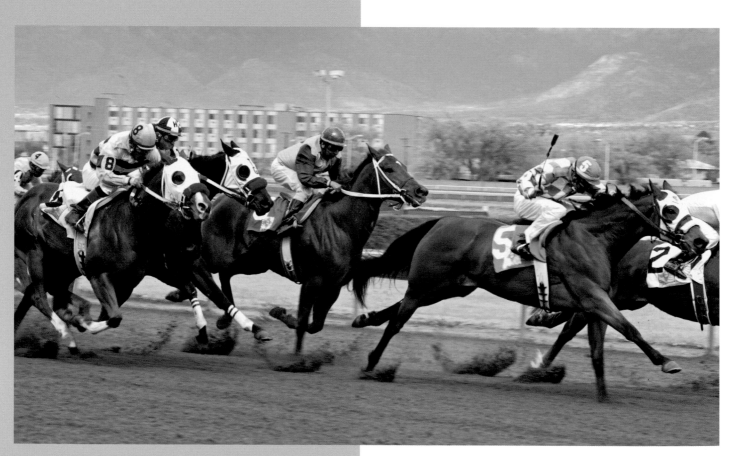

Horse races are a big crowd pleaser at
The Downs, part of Expo New Mexico.

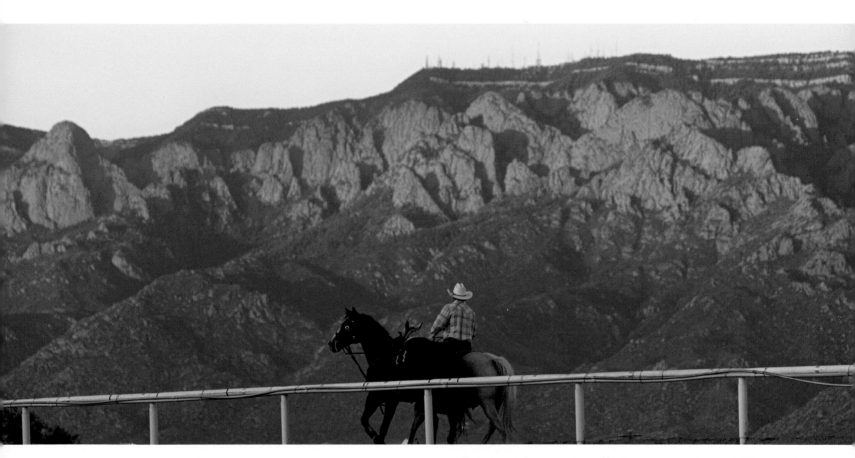

Albuquerque is horse country and hosts numerous equine events. Here, a cowboy trots out his horse before a rodeo at the New Mexico State Fair.

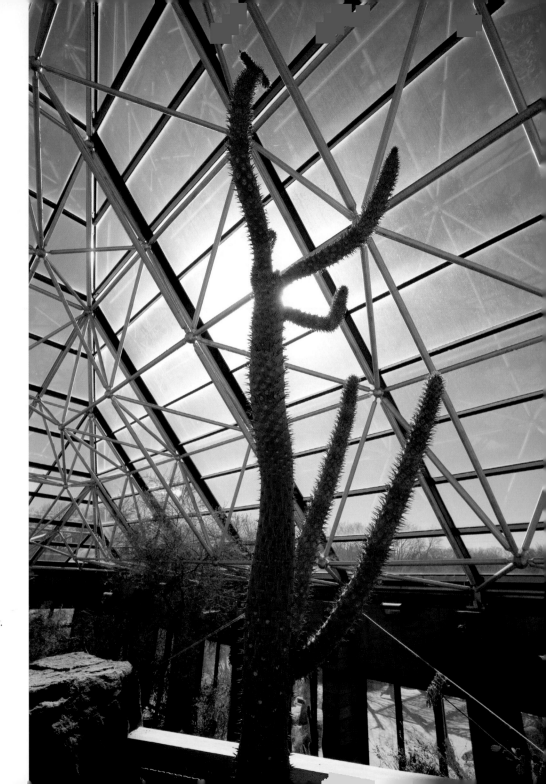

The Río Grande Botanic Garden has ponds, fountains, and extensive gardens on 36 acres. This Madagascar palm grows in the 10,000-square-foot glass conservatory.

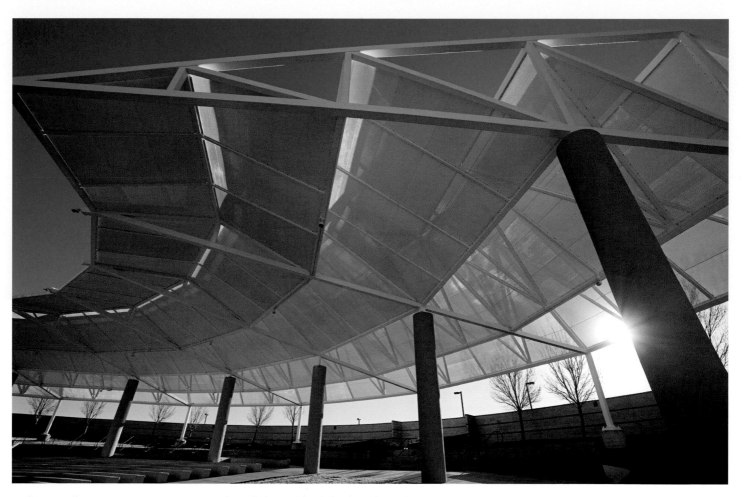

Audiences at the New Mexico Veterans Memorial Amphitheater take shelter from the sun beneath this artfully designed canopy.

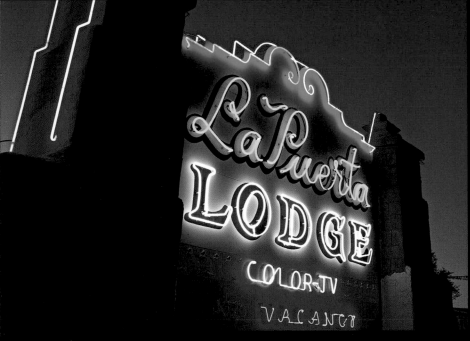

La Puerta Lodge, built in 1949, still promises color
television to travelers seeking rest along Route 66.

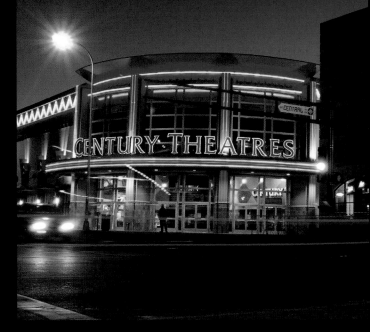

Century Theatres anchor the downtown entertainment scene. Nearby are
lively clubs and unique restaurants to make it a full night on the town.

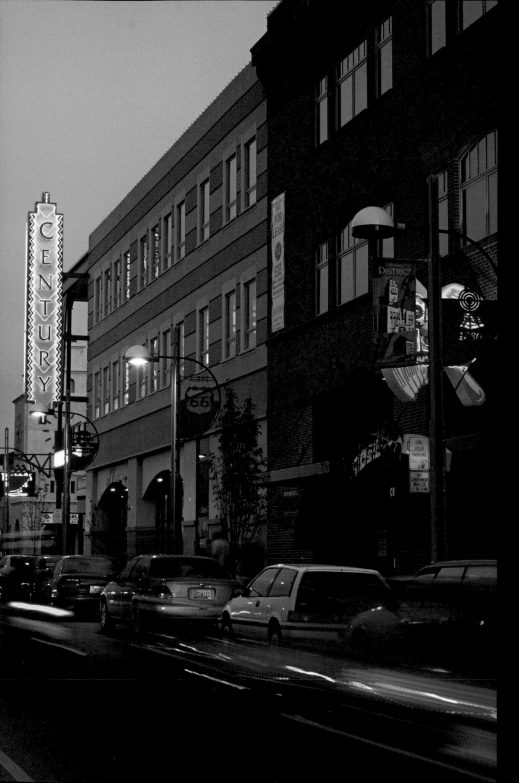

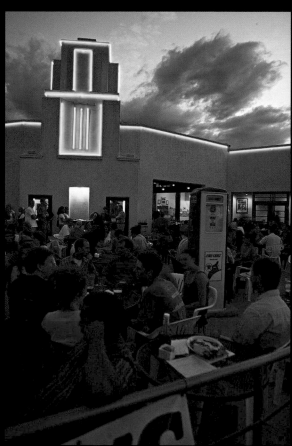

ABOVE: Patrons fill the comfortable, trendy Kelly's Brewpub. The patio scene was a bit less exciting in 1939, when the building served the Jones Motor Company.

LEFT: The city is inviting and vibrant. Lampposts decorated with steel cutouts tout the attractions and history of Albuquerque and New Mexico.

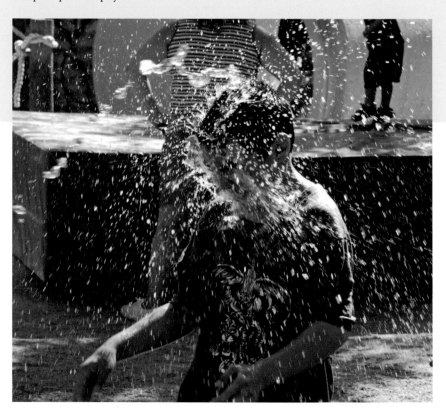

FACING PAGE: Water cascades down the Civic Plaza Fountain. Numerous events are held in Civic Plaza, including Summerfest, which is held Saturday evenings in June and July.

LEFT: Kids (and adults) can enjoy an afternoon of whimsy in the Children's Fantasy Garden, part of Río Grande Botanic Garden.

BELOW: Children take a break from visiting the animals at the Río Grande Zoo to cool off in the splash park and play area.

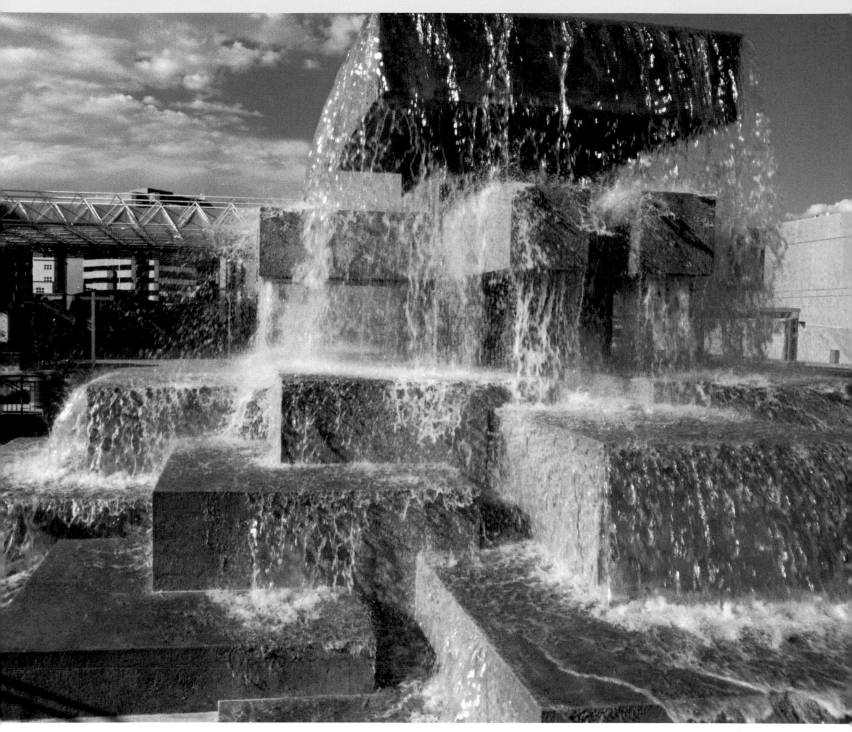

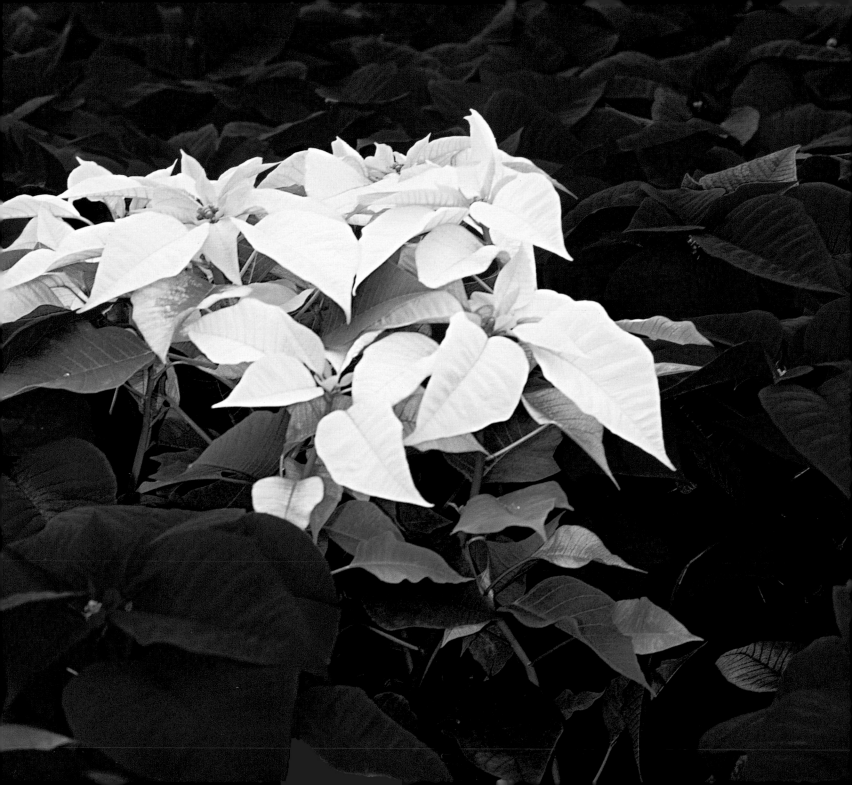

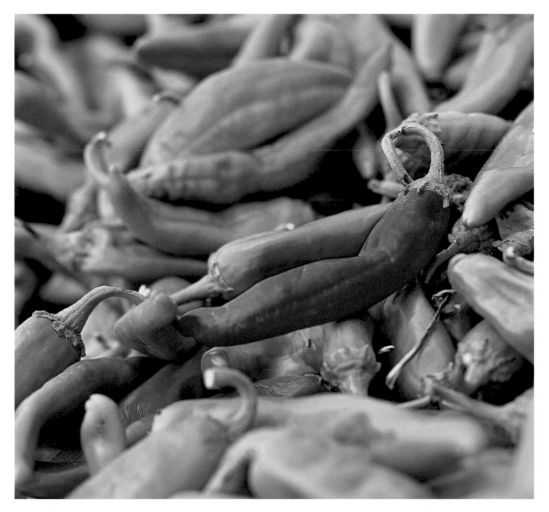

ABOVE: The first sign of autumn: a ripe, red chile pepper. Sold fresh, dehydrated, canned, frozen, and pickled, chiles are among the top agricultural commodities in the state.

FACING PAGE: Ready to be shipped out for the Christmas holiday, poinsettias fill a commercial greenhouse.

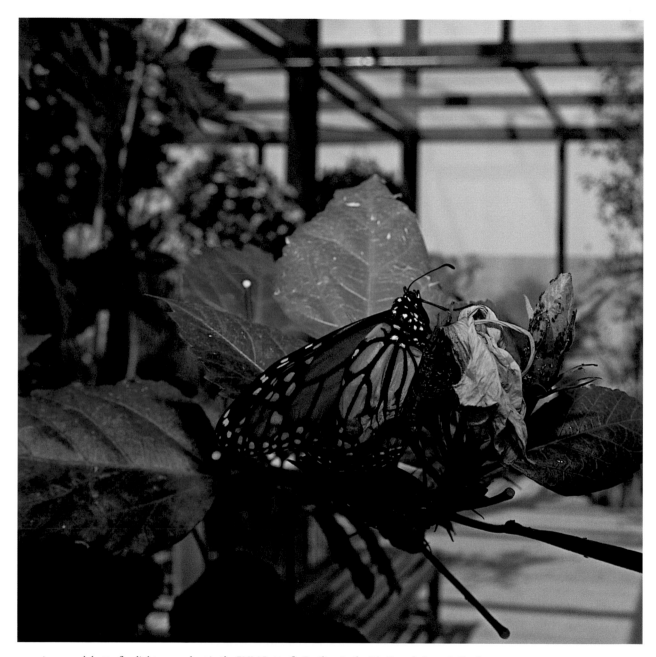

ABOVE: A monarch butterfly alights on a plant in the PNM Butterfly Pavilion in the Río Grande Botanic Garden.

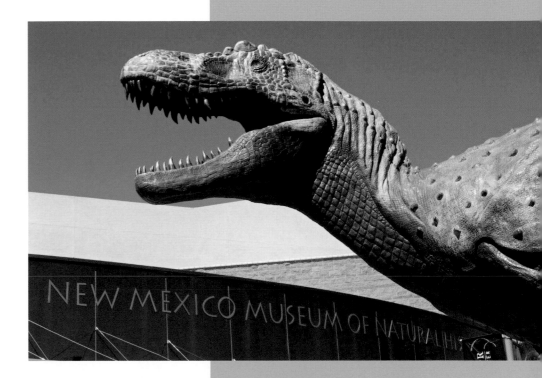

RIGHT: Dinosaurs, rocks, plants, and even hands-on reptile experiences await the inquiring minds of visitors who tour the New Mexico Museum of Natural History and Science.

BELOW: Bill Gates started Microsoft in Albuquerque, and this permanent exhibit in the New Mexico Museum of Natural History and Science documents the Personal Computer Revolution.

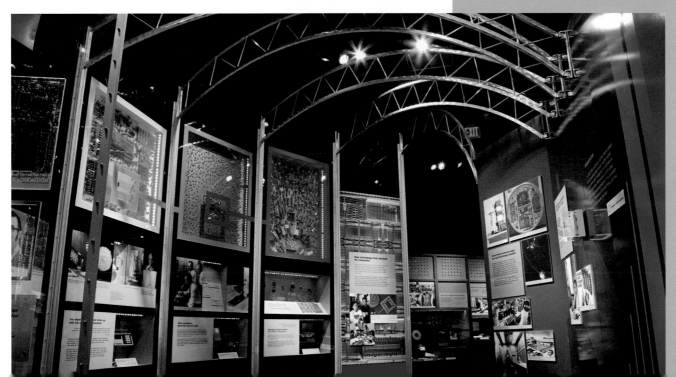

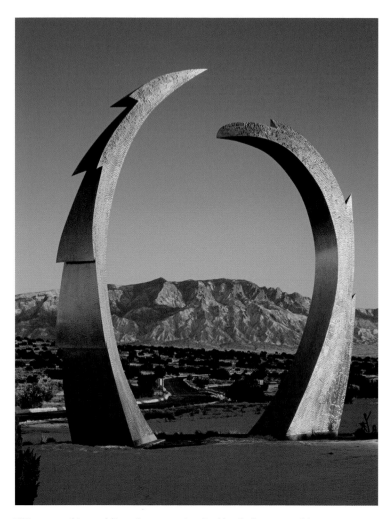

This eye-catching public sculpture was inspired by the breeze-catching stems of blue grama, a nutritious and hardy native grass.

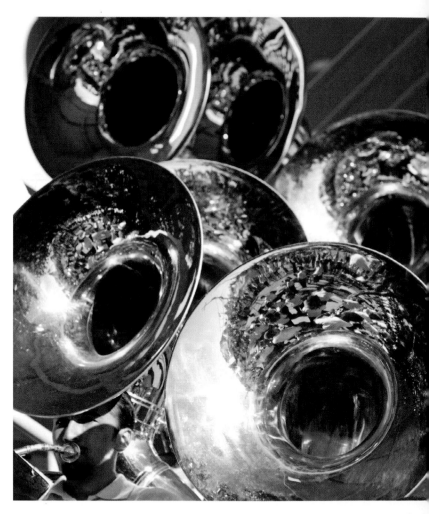

Tubas tooting tunes, toted by the New Mexico State University marching band.

Hang onto your hats! The midway comes alive every night during the State Fair.

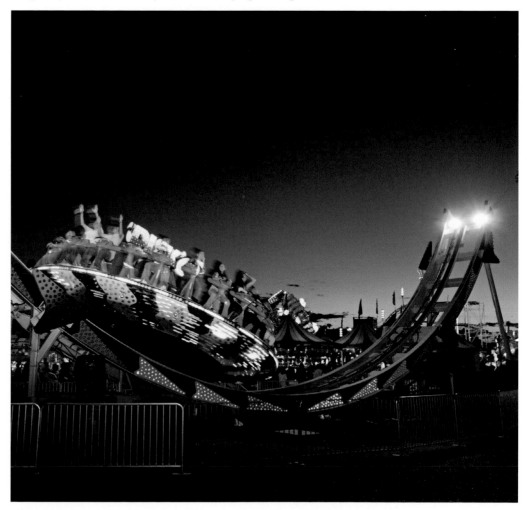

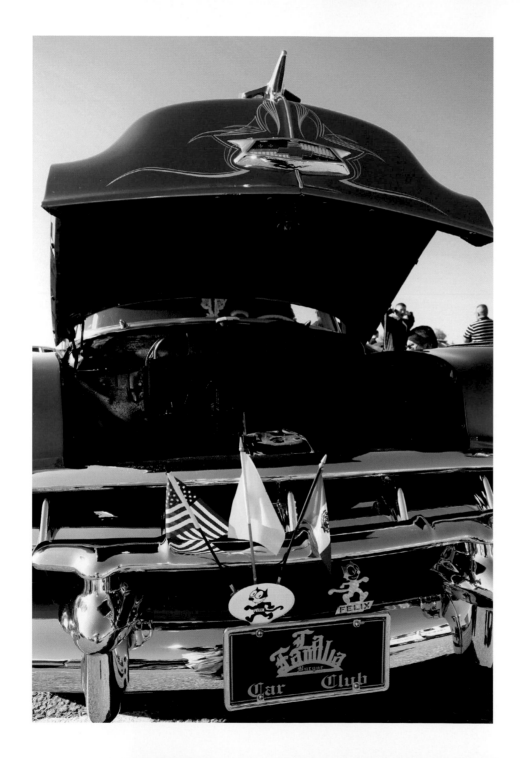
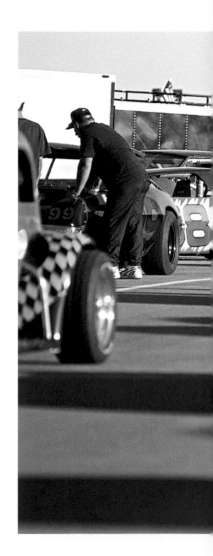

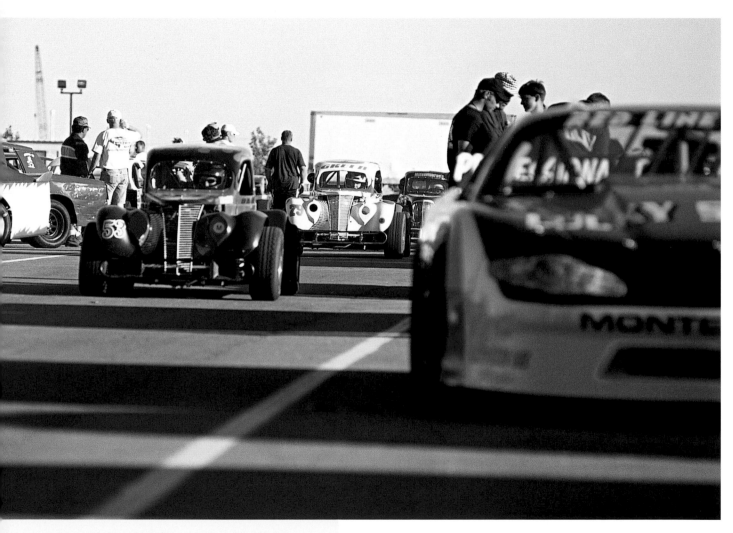

FACING PAGE: Polished to a high shine, this classic low-rider is one of many at a car show in historic downtown Albuquerque.

ABOVE: Race aficionados mill around their cars before the start of speed events at Sandia Motor Speedway.

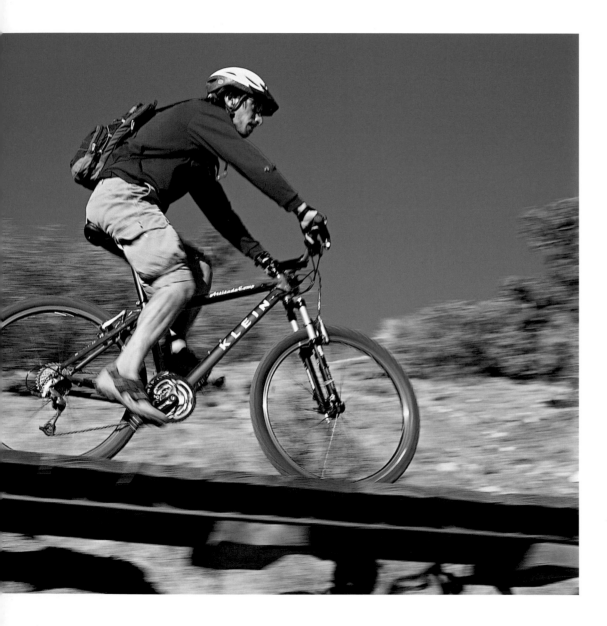

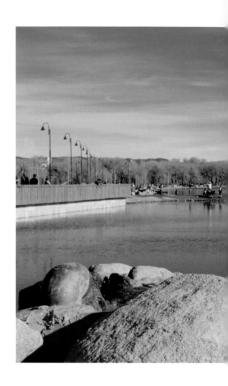

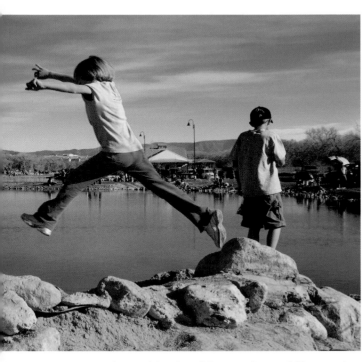

ABOVE: Tingley Beach has three fishing ponds, a model-boat pond, bike trails, and room for just plain messing around on the rocks.

RIGHT: Rock climbing and bouldering, what this young woman is doing, are so popular the city offers seminars to teens to teach them how to climb safely.

FACING PAGE: Albuquerque has an extensive system of footpaths and bicycle trails that lead from the city to the foothills. Metro-area hikes lead to waterfalls, through the pines, and across meadows.

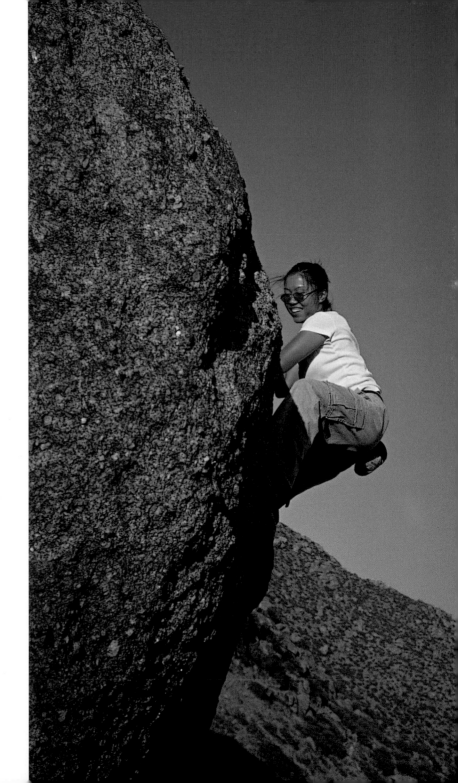

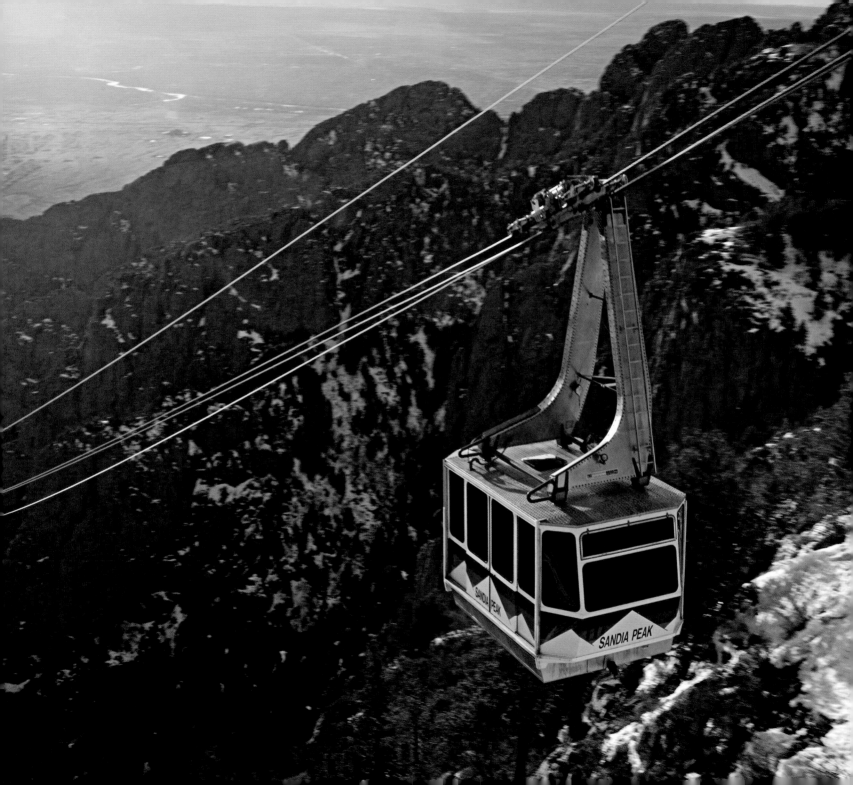

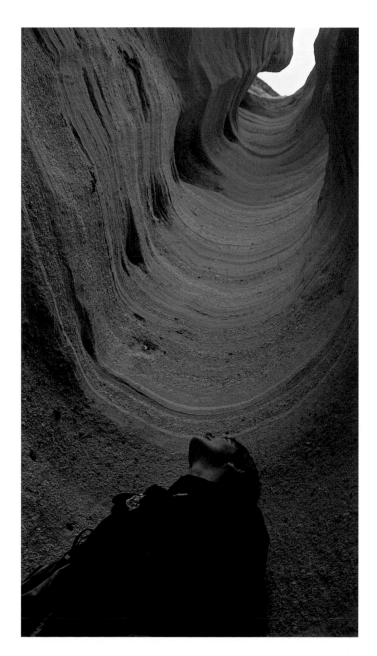

LEFT: The Río Grande Rift fractured the earth's crust and allowed magma to rise to the surface. Over the eons, wind and sand have shaped the soft volcanic tuff into fascinating peek-a-boo shafts and other geological oddities.

FAR LEFT: Sandia Peak Tramway is the world's longest passenger tram, spanning 2.7 miles as it climbs more than 3,800 vertical feet. People often ride to the top to watch the sun set and descend in the dark above Albuquerque's glittering lights.

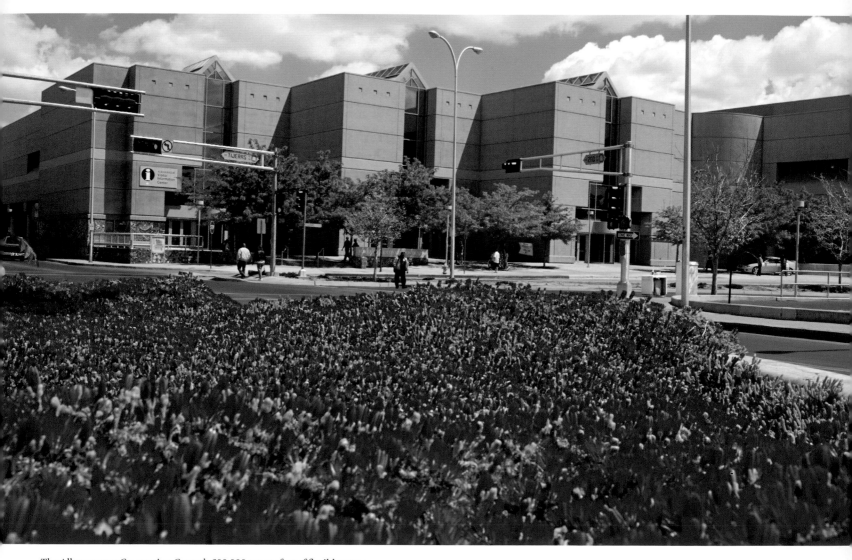

The Albuquerque Convention Center's 600,000 square feet of flexible space hosts activities ranging from symphonic concerts to trade shows.

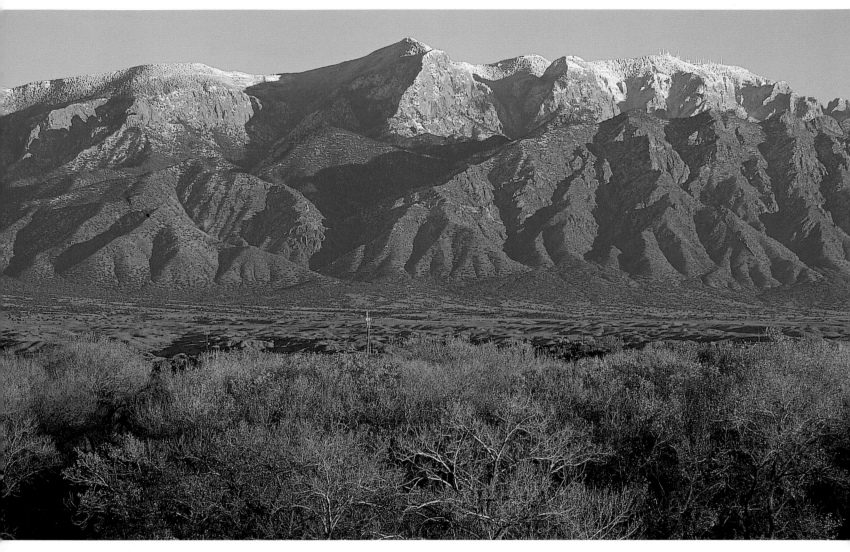

The Sandia Mountains are composed of granite formed more than a billion years ago
from cooling magma; they are capped by 300 million-year-old fossil-bearing limestone.

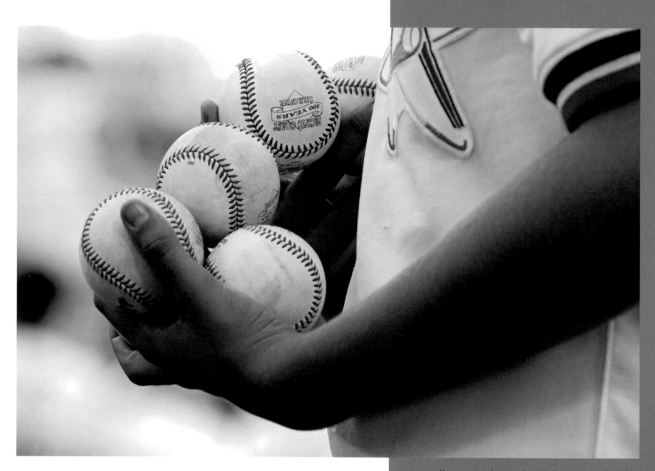

ABOVE: Albuquerque's AAA baseball team is called the Isotopes, in honor of the extensive nuclear research carried out in New Mexico over the decades.

FACING PAGE: A well-used bridge at Tingley Beach provides a safe way to learn to fish in the ponds stocked with rainbow trout. Tingley is part of the extensive BioPark—Albuquerque's premier outdoor attraction—comprising the Río Grande Zoo, Albuquerque Aquarium, and the Río Grande Botanic Garden.

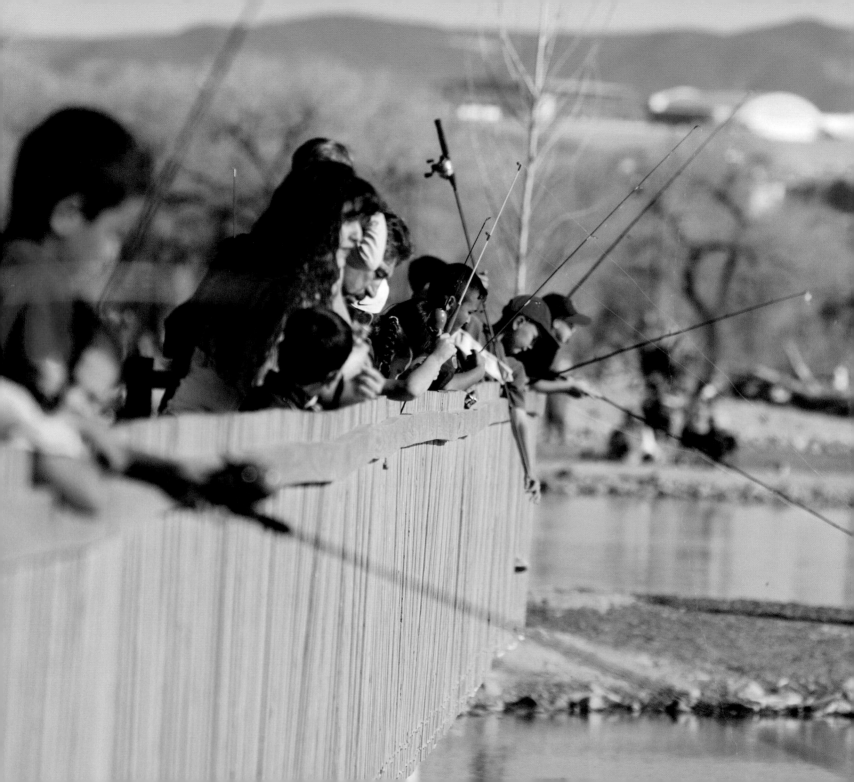

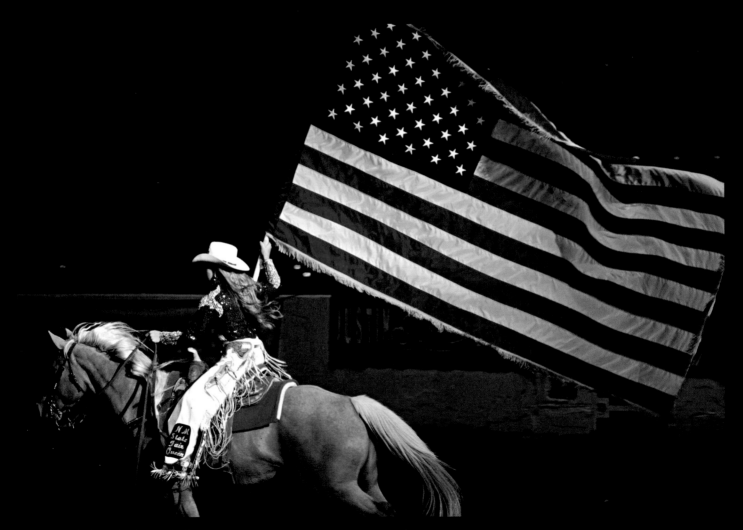

Welcome to the State Fair Rodeo! The fair queen always carries Old Glory in a ceremonial gallop around the arena before the rodeo begins each night.

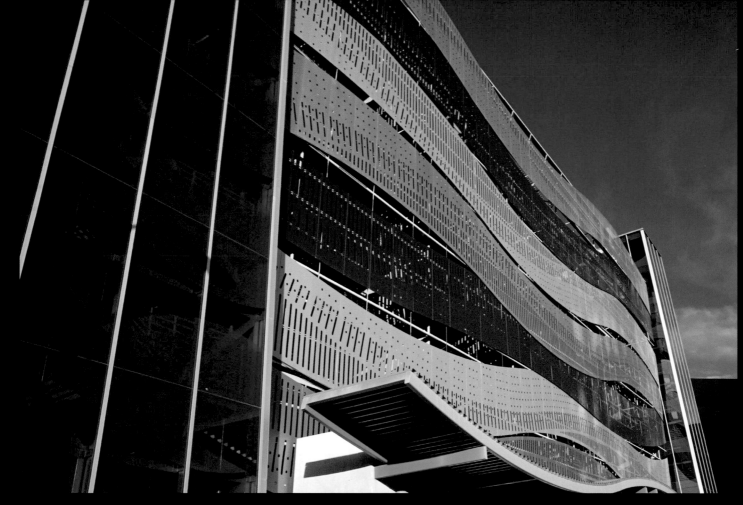

Who says parking has to be dull? This functional multi-story garage uses unique visual effects to keep the downtown cityscape interesting.

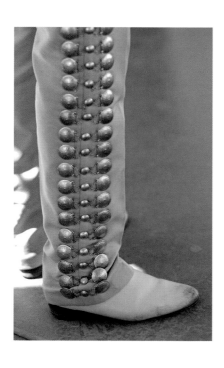

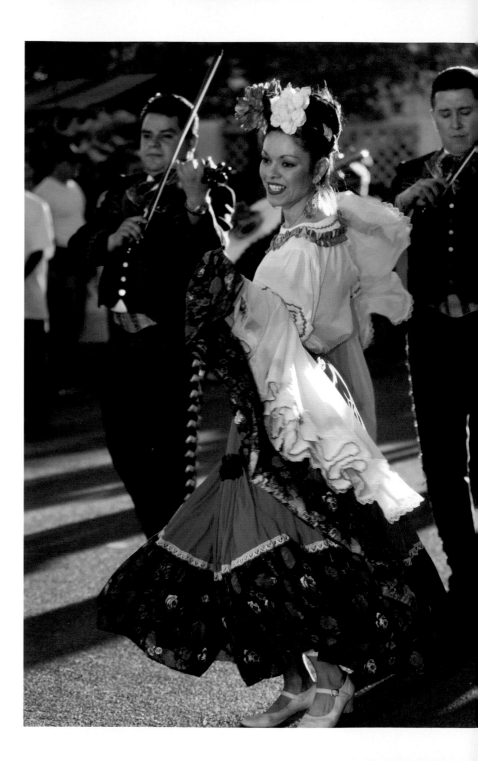

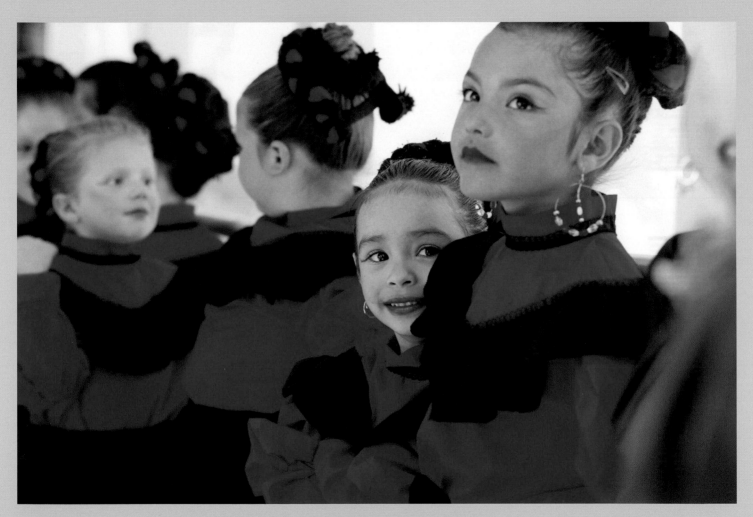

ABOVE AND FACING PAGE: When it's time for a fiesta, folk dancers and mariachi band musicians wear the highly ornamented, very traditional garments of old Mexico. The music is known for its foot-stomping rhythms and catchy melodies, and the female dancers enhance their action with swirling skirts and tiered ruffles.

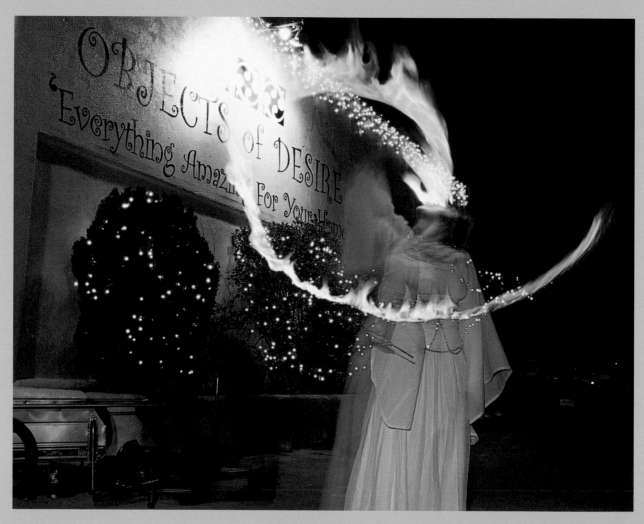

ABOVE: Hot lips! A street performer adds flames to the holiday décor in the Nob Hill shopping district.

FACING PAGE: A luminaria is a candle placed in a bed of sand inside a paper bag. By tradition, they are set out to light the way for the Christ Child. Each Christmas season, thousands of luminarias line the plaza, streets, and walkways of Old Town.

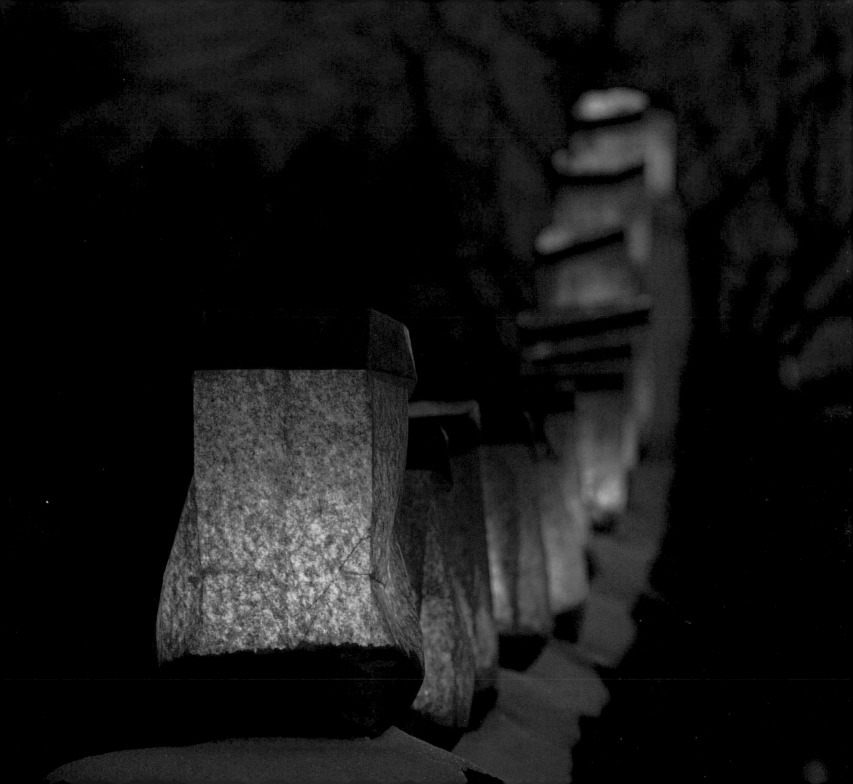

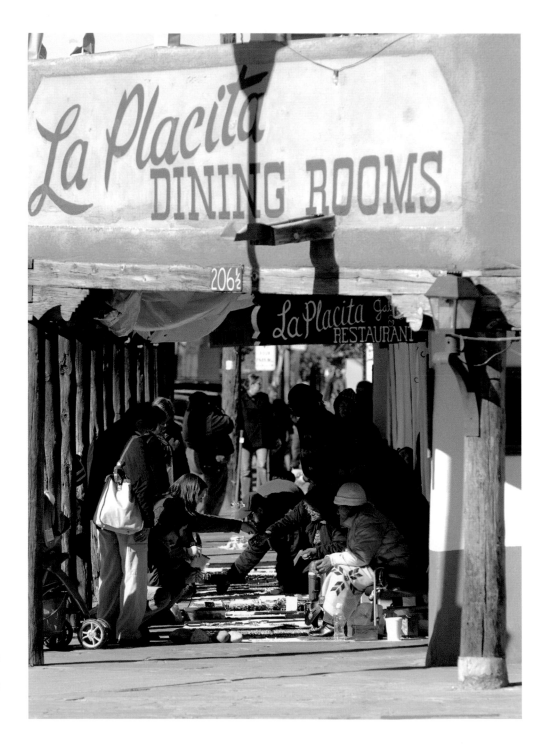

RIGHT: Meet and greet on the street. Artisans and shoppers discuss pieces and prices under a portal on the plaza. Old Town Plaza is a popular gathering place, and you may chance upon a wedding or other social event while you're browsing the handmade jewelry.

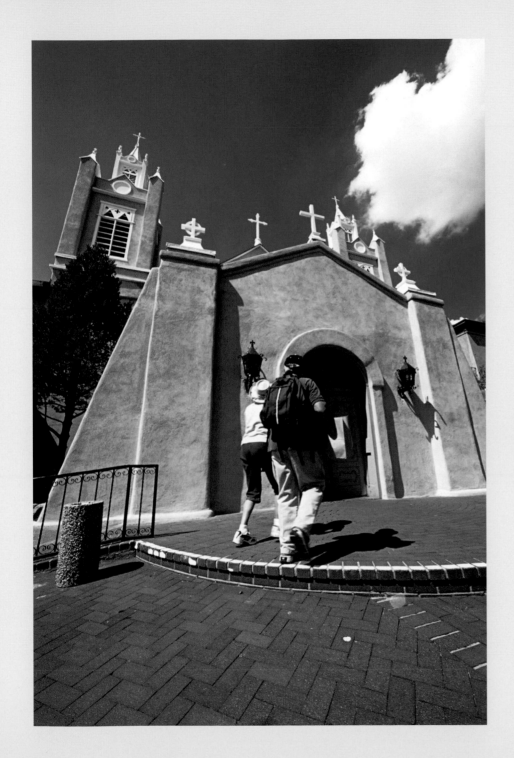

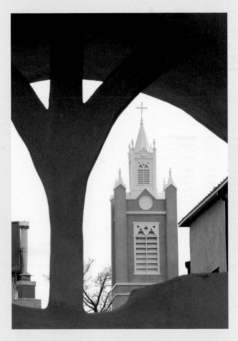

LEFT AND ABOVE: San Felipe de Neri Church, listed on the National Register of Historic Places, was completed in 1793 and replaced the original 1706 structure. The village of Albuquerque was initially laid out in the traditional Spanish pattern of a central plaza surrounded by a church, homes, and government buildings.

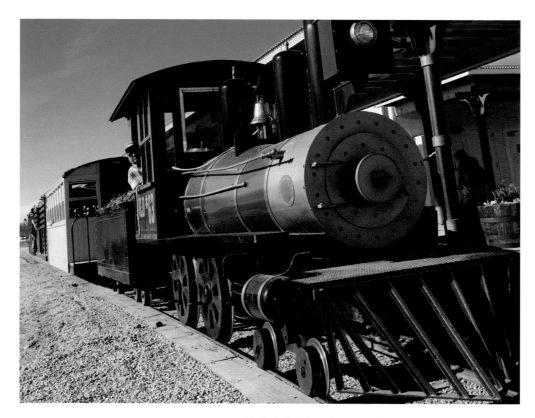

ABOVE: All aboard! A charming open-air, narrow-gauge train connects the various attractions of the Albuquerque BioPark. Here, the train awaits passengers at the depot near the Río Grande Zoo.

RIGHT: Can he do it? Bronc riders must stay on a full eight seconds—and do it in style—if they want a chance at winning big rodeo money.

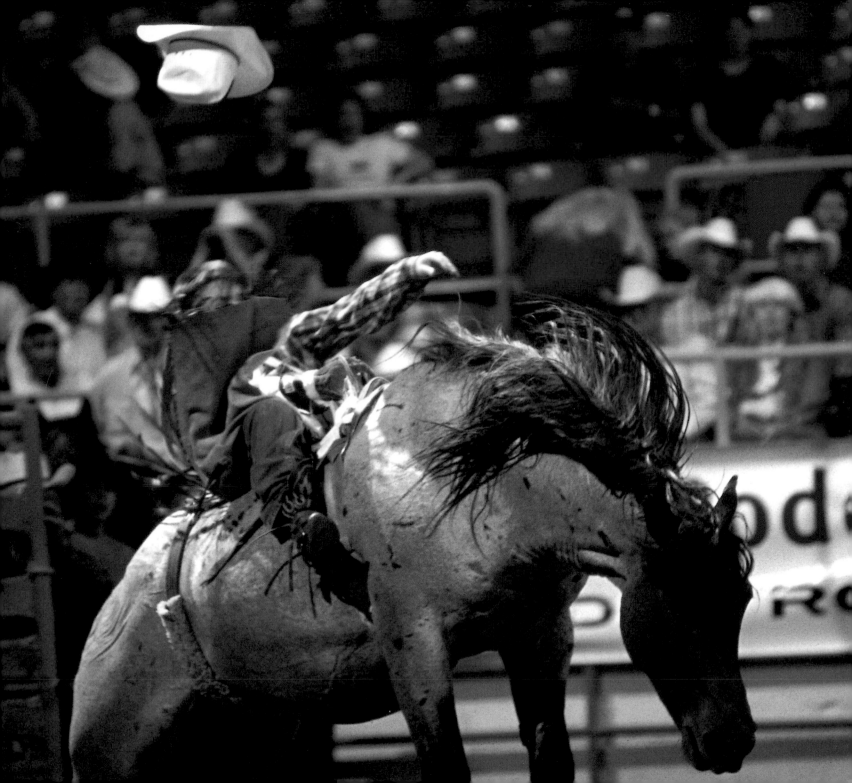

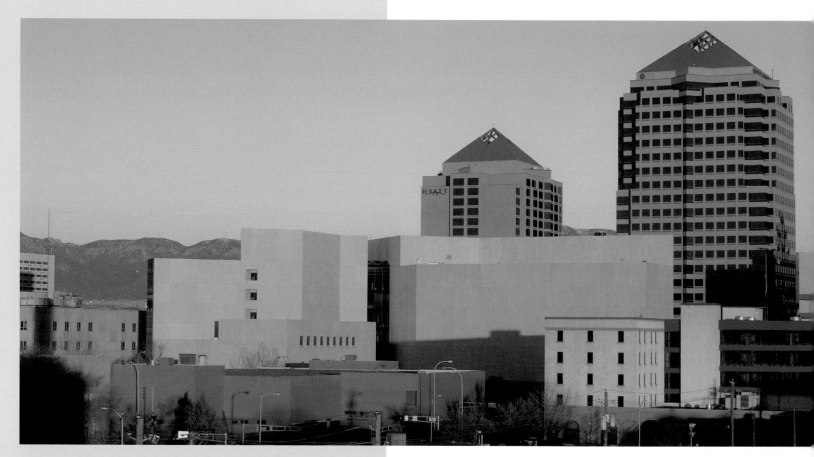

Albuquerque is a thriving center of commerce for New Mexico.
Today, Albuquerque is affectionately nicknamed "Duke City"
because in 1706, Provincial Governor Cuervo y Valdez named the
town to honor the Viceroy of New Spain, the Duke of Albuquerque.
The original village of Alburquerque (note the different spelling)
is located in western Spain near Portugal.

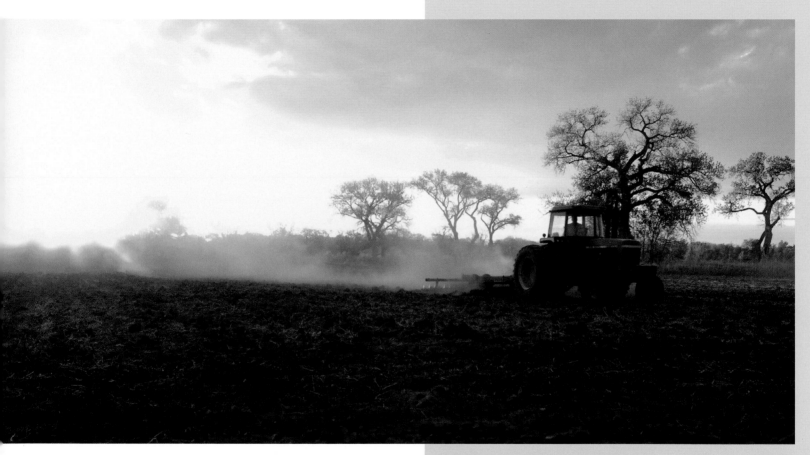

New Mexico encompasses 121,593 square miles.
The top agricultural products are cattle, dairy products,
hay, nursery stock, and chiles.

RIGHT AND FACING PAGE: Farms surround Albuquerque, perfect for people who like to pick their own produce or buy direct from the farm at road-side stands. The weekly Downtown Farmer's Market attracts vendors who bring fresh, locally grown produce right into the city.

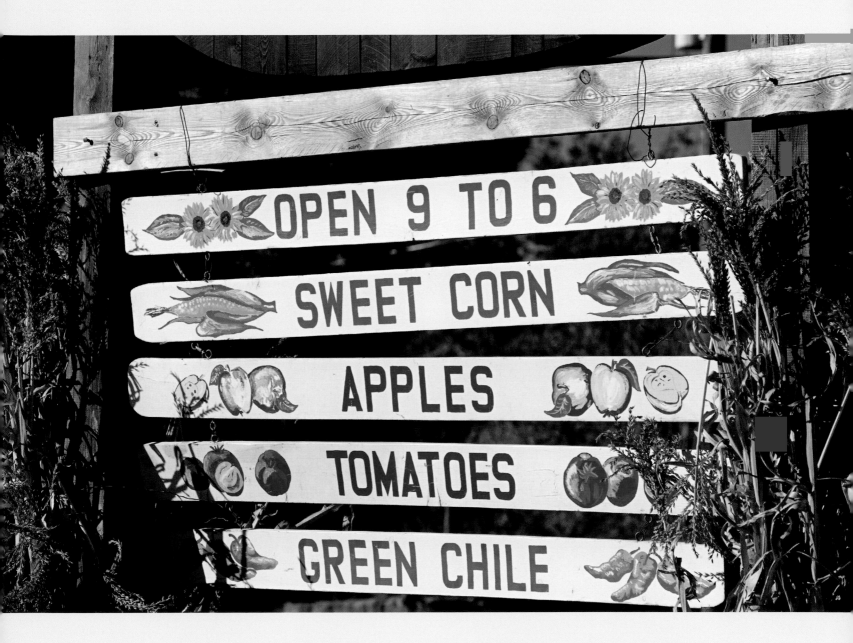

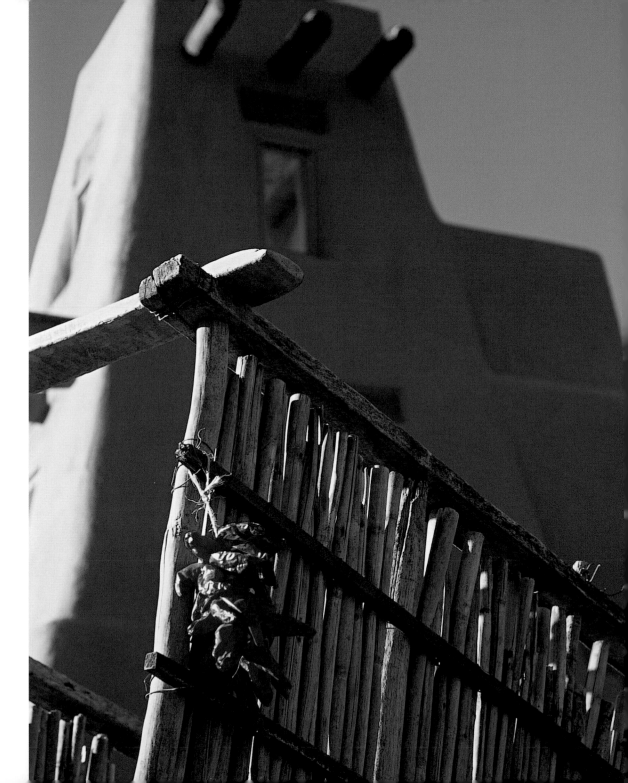

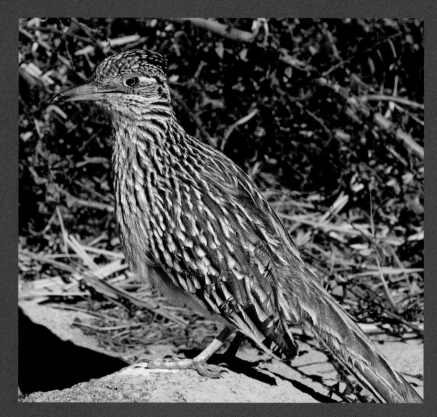

ABOVE: New Mexico's state bird is the roadrunner, seen here in a rare moment of holding still. Roadrunners prefer foot travel to flying and have been clocked at speeds of 15 miles per hour. These 10- to 12-inch-tall birds eat insects, lizards, centipedes, mice, and snakes.

FACING PAGE: A ristra of chiles decorates a rustic cart in Corrales. The home is constructed of adobe bricks that are sun-baked, mortared with mud, and protected with a layer of mud or cement.

KIP MALONE
PHOTOGRAPHER

Kip Malone, a semi-native Albuquerquian, spends his days working on photo assignments for ad agencies and magazines.

His adventures with the camera yield this short list of photographic wisdom:

- Rattlesnakes are best photographed with a long telephoto lens.
- Police officers in most countries don't like their pictures taken.
- Small camera parts are very difficult to find in tall grasses.
- While cameras don't bounce, strobe lights do, but they still break.
- Always remember to bring rain gear—especially when it's sunny.
- And keep a close eye on frightened livestock when photographing in enclosed arenas.

To contact him or view more of his work, please visit www.KipMalone.com.